Body&Soul

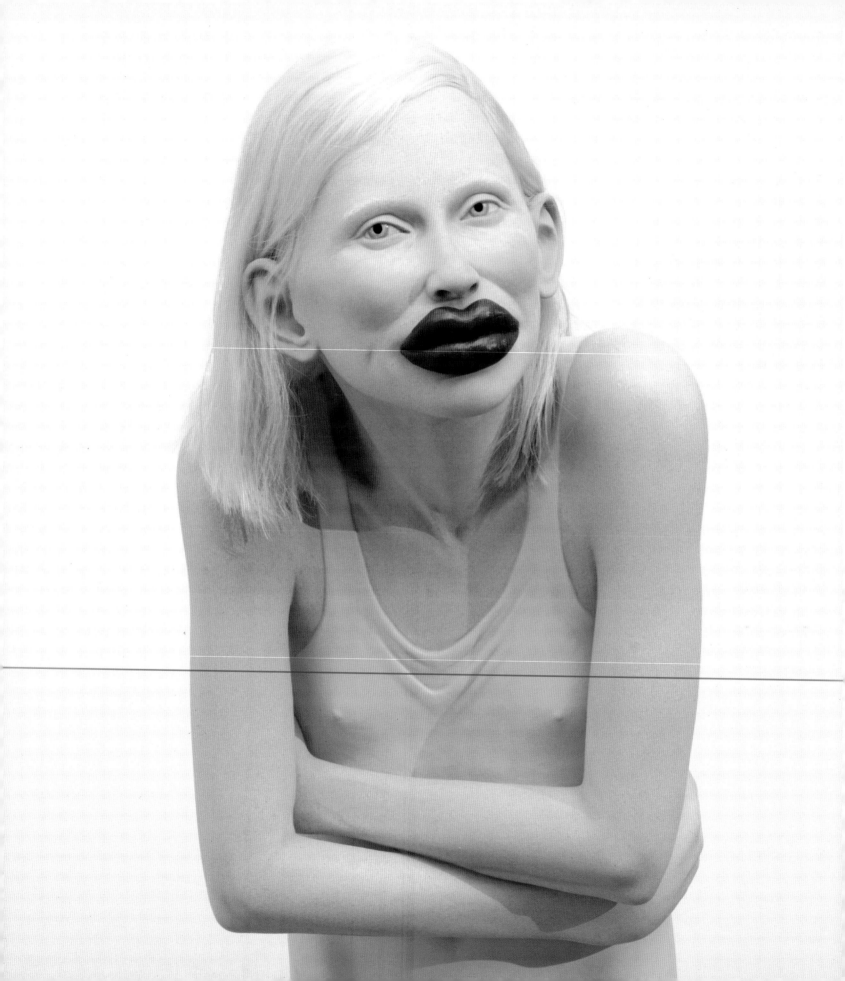

Body&Soul

New International Ceramics

Wendy Tarlow Kaplan

Martin S. Kaplan

Laurent de Verneuil

Dear Larry and Judy,

Thank you for thee wonderful tour of your magnificent home and gardens!

Martin & Wendy

8/23/17

Museum of Arts and Design, New York

Museum of Arts and Design
2 Columbus Circle
New York, New York 10019

Published in conjunction with the exhibition
Body & Soul: New International Ceramics, organized
by Wendy Tarlow Kaplan and Martin S. Kaplan
and the Museum of Arts and Design
September 17, 2013–March 2, 2014

museum of arts and design

Major support for *Body & Soul: New International Ceramics*
is provided by George Abrams, Kate and Gerald Chertavian,
Chubb Insurance, Friends of Contemporary Ceramics, the
Glassman Family Fund at the Boston Foundation, Hunt
Alternatives Fund, Nancy Klavans, Cheryl and Philip
Milstein, David and Susan Rockefeller, Michael and Karen
Rotenberg, Shepherd Kaplan LLC, Lisbeth Tarlow, and five
anonymous donors, with additional support from a group
of private donors.

Edited by Barbara Burn
Designed by Linda Florio, Florio Design

ISBN: 978-1-890385-27-9

Printed and bound by Global PSD, China

All measurements: height x width x depth,
unless otherwise noted.

Front Cover:
Daphné Corregan
Smeared Face (detail), 2012
Courtesy of the artist
Photo: Gilles Suffren

Back Cover:
Kim Simonsson
Untitled, 2013
Courtesy of the artist
Photo: Kim Simonsson

Frontispiece:
Tip Toland
Grace Flirts (detail), 2008
Courtesy of Barry Friedman Ltd.,
New York
Photo: Andrew Bovasso

Acknowledgments

THE MUSEUM OF ARTS AND DESIGN has generously embraced this exhibition, and several staff members have been critical to its success. The co-curators and I especially recognize their contributions. The astute judgment, enthusiasm, and leadership of chief curator David Revere McFadden were central to the entire team's working effectively. Assistant curator Thea Giovannini's excellent organizational skills and calm disposition kept all the artists, essayists, and curators on target. Curator of exhibitions Dorothy Globus's visual and spatial talents, along with the efforts of exhibition manager Matthew Cox, have created a dramatic installation. Head registrar Ellen Holdorf and registrar Carla Hernandez managed the complex transportation of both fragile and large-scale works of art. Curatorial fellow Lyndsay Bratton assisted in writing the artist biographies. We thank all of the staff at MAD for their commitment to this project.

Co-curators: Martin S. Kaplan provided encouragement, guidance, and support in all aspects of this complex international exhibition and played a major role in bringing this enterprise to fruition. Laurent de Verneuil, a brilliant Paris gallery figure and curator, introduced us to many of the French and other international artists. He guided us on numerous visits to artists' studios in and around Paris, and he brought taste and artistic judgment to all of our decisions.

Catalogue and Design: Linda Florio's imaginative design of the catalogue and graphics brilliantly reflect the boldness of the sculptures and the essence of the exhibition. We thank Barbara Burn for her careful editing of the catalogue.

Essayists: Several distinguished individuals contributed their perspectives on the issues presented in *Body & Soul*. Their thoughtful and engaging essays greatly enhance the meaning of the exhibition, and their profound knowledge and experience in the arts brought gravitas to our thinking and the catalogue. We are very grateful to Ronne Hartfield, Peter Held, Karen and Michael Rotenberg, and W. Richard West Jr.

Advisors: We are indebted to many for their willingness to provide advice as we conceptualized a figurative ceramic exhibition addressing social issues: Karen and Michael Rotenberg, Daphné Corregan, Maria Lund, Patrick Loughran, Hélène Huret, Leslie Ferrin, Barry Friedman, Carole Hochman, Osvaldo Da Silva, and Chantal Helenbeck.

Loan Assistance: Several galleries and private collectors were gracious in identifying and arranging for loans of significant works of art. Special thanks to Barry Friedman Ltd., New York; Claudine Papillon Galerie, France; FerrinContemporary, USA; Galerie Anne de Villepoix, Paris; Galerie Emmanuel Perrotin, Paris; Galerie Eric Dupont, Paris; Galerie Eva Hober, Paris; Goodman Gallery, Johannesburg and Cape Town; Haunch of Venison, New York; Eileen S. Kaminsky Family Foundation; Lehmann Maupin, New York and Hong Kong; Mike Weiss Gallery, New York; Patrajdas Contemporary, Philadelphia; Sèvres – Cité de la Céramique, Sèvres, France; The Speyer Family Collection, New York; Karen Zukowski and David Diamond.

Patron and Major Supporters: François Delattre, Ambassador of France in the United States, honors us as patron and expresses his pride, not only in the role of French artists but especially as the exhibition reflects universal values of France. Major support has been provided by George Abrams, Kate and Gerald Chertavian, Chubb Insurance, Friends of Contemporary Ceramics, the Glassman Family Fund at the Boston Foundation, Hunt Alternatives Fund, Nancy Klavans, Cheryl and Philip Milstein, David and Susan Rockefeller, Michael and Karen Rotenberg, Shepherd Kaplan LLC, Lisbeth Tarlow, and many other donors.

We are grateful to Friends of Contemporary Ceramics for the generous support of this catalogue.

Wendy Tarlow Kaplan
Curator

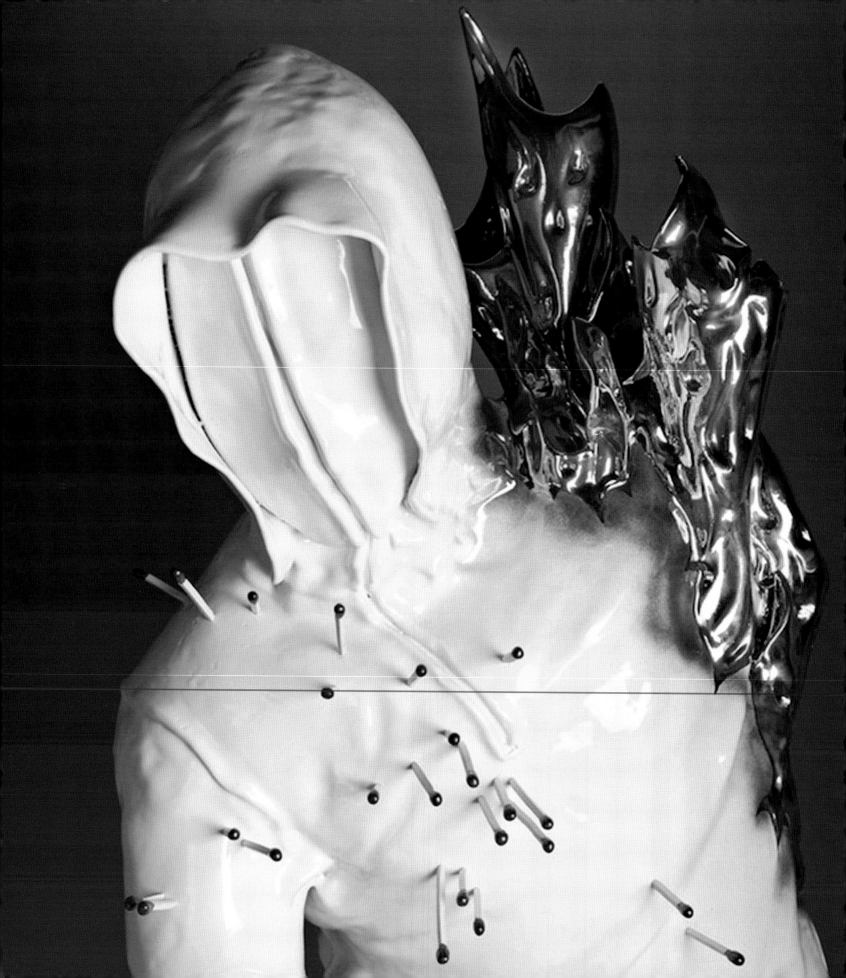

Bodies Speaking Out

I AM PROUD to serve as Honorary Patron of the impressive exhibition *Body & Soul: New International Ceramics* presented by the Museum of Arts and Design in New York. This show brings together twenty-four contemporary artists, thirteen of whom live and work in France. While I am very pleased regarding the French representation, I believe that this exhibition tells a story unrelated to a specific nationality.

The artists speak to the public on social issues through the medium of clay. Ceramics convey a tangible, incarnate, and emotional expression of pain and violence inflicted on people by others and truly reach the core of the human condition. Through the engagement of international artists, this exhibition successfully demonstrates how art can define and address universal issues. This idea brings me back to France, for universalism is one of my country's most cherished ideals.

I thank Wendy Tarlow Kaplan and Laurent de Verneuil for their brilliant work and fruitful collaboration. This partnership is a shining example of the strength and vitality of our French-American bond.

François Delattre
Ambassador of France in the United States

Marc Alberghina
Saint Sébastien B (detail), 2012
Courtesy of the artist

Millions of Thumbprints: Clay and Culture

THE AMERICAN AUTHOR John Updike once wrote: "You cannot help but learn more as you take the world into your hands. Take it up reverently, for it is an old piece of clay, with millions of thumbprints on it."

In 1925 an extraordinary archaeological discovery was made in Dolní Věstonice, which is today in the Czech Republic. The site dates to the Upper Paleolithic Period, approximately 26,000 years before the present day. The excavations revealed a stunning cache of art made from clay, including what has come to be considered the oldest ceramic figure in the world, designated the Venus of Dolní Vestoniče. With her broad hips and weighty breasts prominently depicted, the figure has generally been interpreted as related to fertility beliefs. If so, the clay figure serves as a physical and tangible manifestation of spiritual and cultural concerns, setting the stage for a virtually uninterrupted lineage of man-made human figures used to express inner states of being.

What makes this particular figure so poignantly memorable is that the fingerprint of a child is permanently embedded in the raw clay, possibly the first of the "millions of thumbprints" that have marked the authorship of ceramic figures for millennia.

From that time to this, clay has never lost its power to convey thoughts, beliefs, and concerns of individuals and cultures. Just this year, archaeologists explored a Neolithic site in Greece (ca. 5800–5300 BCE) with no less than three hundred clay figures, one of the largest finds known. It has been posited that the figures, both male and female, document not only the aesthetic vision of the culture but also issues of gender and identity. The Bible is replete with many references to clay as a metaphor for human life: "We are the clay, you are the potter; we are all the work of your hand," praised Isaiah.

From ancient Greece through the Etruscans and Romans to the Renaissance and, ultimately, to the twenty-first century, clay has remained the most direct and immediate way of expressing ideas—beyond metal, glass, wood, and fiber, all of which are technically more demanding. Daphné Corregan, whose work is included in this exhibition, states: "No material other than clay would suit my

way of working, particularly with the more figurative work . . . [with] surfaces smoothed and defined by the pressure of my fingertips." Akio Takamori, also in the show, says it this way: "The material is tactile, and at this point, my strokes are intuitive actions and reactions to it."

The immediacy and tactility of clay, its ability to record the most delicate of gestures and, likewise, the most subtle and subjective thoughts and emotions, are brilliantly documented in *Body & Soul: New International Ceramics*. The exhibition was conceived and organized by guest curator Wendy Tarlow Kaplan, whose expertise, enthusiasm, and experienced eye are reflected in every aspect of the exhibition and catalogue. With her co-curator Martin S. Kaplan, she visited the artists in their studios to select the works that best convey the timely significance of this exhibition. Co-curator Laurent de Verneuil contributed his knowledge of and passion for contemporary ceramic art in France, and his insights further guided the curatorial process as he joined their team at the outset of the project. The Museum also wishes to thank the essayists who contributed such pertinent contributions to the publication. At MAD, assistant curator and project manager Thea Giovannini worked assiduously to realize both exhibition and the catalogue, so sensitively designed by Linda Florio and edited by Barbara Burn. The elegant installation design was created by Dorothy Twining Globus, MAD's curator of exhibitions, and registrars Ellen Holdorf and Carla Hernandez were, once again, conscientious and diligent in their arrangements for bringing the art to MAD.

Since 1956, when the Museum of Arts and Design opened in its first manifestation as the Museum of Contemporary Craft, we have underscored our commitment to ceramics in general, and ceramic sculpture in particular. *Body & Soul: New International Ceramics* is the latest manifestation of how the humble and quotidian material born of the earth itself is once again claiming center stage in contemporary art. While the works chosen for this exhibition speak eloquently, poignantly, or stridently of issues and concerns of our immediate time, they are also inextricably connected with works made nearly 30,000 years ago that today still tell the story of what makes us human.

David Revere McFadden
William and Mildred Lasdon Chief Curator
Museum of Arts and Design

THE EXHIBITION *Body & Soul: New International Ceramics* presents sculpture in clay expressing potent ideas, which confront critical issues that challenge our societies worldwide: bullying, sexual abuse, gun violence, fear, and rebellion, as well as identity, anxiety, and environmental degradation. Of the twenty-four ceramists, thirteen are from France; others are from the United States, the United Kingdom, Denmark, Sweden, Spain, and Finland; several convey the history and experience of France in North Africa. Many come to clay as draftsmen, painters, or sculptors, and many are showing their work in the United States for the first time.

The artist with a social conscience who models in clay strives to capture both immediacy and passion through tactile manipulation. With a focused purpose, he or she creates a specific message of historic or current concern. Throughout art history, there have been two tracks of creativity: one that constructs "art for art's sake" (Victor Cousin, nineteenth-century French philosopher) and another that gives voice to a cause—historical, philosophical, or societal. In recent years, the human figure has enjoyed a renaissance among artists around the world. *Body & Soul: New International Ceramics* underscores the ability of the human form to convey intense emotions. Through the medium of clay, the figure becomes the catalyst for expressing the impact of contemporary pressures.

Each work is motivated by a personal or symbolic experience or history that generates a deep emotional response. These artists have the courage to speak out, inspired by the legacies of the great nineteenth- and twentieth-century artists who demonstrated their passion through painting and sculpture. French romantic painters have had a profound influence on French consciousness through the drama of the visual image. Géricault's *Raft of the Medusa* (1819) and Delacroix's *Liberty Leading the People* (1830) were prime examples of this movement. Auguste Rodin's *Burghers of Calais* (1889), first modeled in clay and then cast in bronze, expresses the pain of civic leaders who were willing to die as their town surrendered during the Hundred Years' War. Francisco Goya's *Los Desastres de la Guerra* (1815) and Pablo Picasso's *Guernica* (1937) address the horror of war with dramatic tension. Picasso wrote: "Art is the lie that enables us to realize the truth." And in our time Anselm Kiefer blends painting and sculpture in large-scale work that screams of the evil of war and genocide.

The impressive artists in this exhibition reflect not only their own experiences and history but also the influence of earlier artists who chose to create art that embraces the challenge of complex and controversial matters. All the artists in this exhibition have taken this courageous path. Nothing is pretty or decorative; each work has poignancy.

We hope that *Body & Soul: New International Ceramics* will promote dialogue and discussion, conversation and contemplation regarding the societal issues and problems that these artists so passionately express. We congratulate and thank them all for their creativity and their commitment to address the human condition with raw power and pathos.

Rather than one major academic essay, we chose to invite several outstanding participants in the art world to offer their insights on the art presented and the issues raised by these artists. We thank them for their thoughtful comments in response to *Body & Soul*.

Wendy Tarlow Kaplan
Curator

Laughing, Crying, Hating

THE END OF THE twentieth century and the beginning of the twenty-first witnessed and are witnessing some major societal upheavals, whose effects have been felt even at the most personal level. The art scene, too, has been deeply affected. Modernist beliefs have been called into question, and conceptual approaches are giving way to works that explore previously denied psychological and emotional dimensions, putting the body and identity at the very heart of art. By giving the human figure a central place within the *Body & Soul* exhibition, the idea is to reflect this new era in which empathy and pathos reign supreme. Returning to the artistic field, pathos embraces all the realms of emotion and sensitivity. According to the French poet and philosopher Pierre Klossowski, it is the only genuine way of apprehending existence, the only "organ of knowledge." Pathos engenders a true creative awareness, enabling access to the essential, a "pathetic knowledge" subject to all that results from an emotional state, whether it concerns "laughing, crying, or hating."

From a formal standpoint, art practices are evolving toward greater freedom. All materials likely to translate or kindle such emotions are summoned without distinction, whether they are new media or traditional materials, such as paint and ceramic. The current exhibition seeks to bear witness to this evolution by taking into consideration works by artists of several nations. They each have their own unique way of using ceramic and attach importance to pathos in artworks that are designed no longer to edify or to question but to make an emotional connection with the viewer. They address the human figure and thus appre-hend one of the most traditional themes in the history of art, evoked by Jean Clair at the centenary of the Venice Biennale in 1995. But today this human figure is that of a humanity that has experienced the '80s and the end of the grand narratives—socialism or capitalism, sexual freedom, belief in the eradication of illness and poverty, never-ending progress. It is also the figure of a humanity that has survived world economic crises, unprecedented epidemics, environmental and nuclear disasters, and the emergence of mass terrorism.

Of course, these ceramic sculptures are exhibited here with and like any other type of medium. We are a long way from the "little world of ceramics" despised by Grayson Perry. Here ceramics is not considered a discipline apart, which, according to the terms of Garth Clark, distinguishes between "visitors" and "day-trippers" and true practitioners. Here it is a question of a material chosen for its intrinsic qualities, its durability and great plasticity, as well as for its chosen or accidental imperfections or its affordability. This is a material that has now become thoroughly assimilated, for as Katie Sonnenborn wrote in 2008 in the context of the seminal *Makers and Modelers* exhibition at the Gladstone Gallery, "collectors and—judging from the number of works created this year—artists are hungry for straightforward, handmade works." It is perhaps ultimately and simply a search for what Henry Moore calls "truth to material." The British sculptor recognized that it is only when a direct and active relationship is established with the material that the latter can play its full role in shaping ideas.

Laurent de Verneuil
Co-curator

Fertile Moments for Figuration in a Time of Flux

ARTISTS HAVE represented the figure in many guises throughout human history. These manifestations reflect the time and place in which they are created, recording timely yet universal and personal expression that reveal aspects of our inner and outer experiences. The urge toward representation in the field of contemporary ceramics has expanded exponentially in recent years, as socially engaged artists strive to make sense of an increasingly complex world. The malleability and tactile characteristics of clay are well suited to capture this shifting focus on figuration.

Globalization, post-9/11 social, economic and political unrest, and other forces influencing today's cultural and social landscapes are continually reshaping what it means to be a ceramic artist in the twenty-first century, revealing previously uncharted territories, and paving the way toward an inclusive and more comprehensive perspective among artists and cultural presenters. Practitioners are assuming a greater role as alternative transdisciplinary producers of knowledge and are creating new models of dialogue with contemporary concerns, which have been marginalized or ignored in the past.

Artists who have chosen to work in the medium of clay are compelled to create for a variety of reasons: personal and private concerns, political and social activism, the search for a humanistic balance in a seemingly all-consuming technological culture. Works are becoming more emotionally charged, mysterious, and unsettling. Innovative content narratives are creating dramatic vignettes that address issues of identity, gender, abuse, and alienation. Viewers respond to the work by drawing their own conclusions and seeking harmony in their own lives.

Body & Soul: New International Ceramics highlights the extraordinary talents of artists active in the United States and Europe. American artist Tip Toland's unsparingly realistic figures conjure up the depths of human emotion, seducing the viewer with her mastery of lifelike detail. Her aim is to give voice to inner psychological and spiritual realms of being. The Danish sculptor Louise Hindsgavl uses her highly crafted modeling skills and the seductiveness of porcelain to lure viewers closer, to unpack the complex fictive narratives. Because of the sculptures' brilliancy, the viewer must seek details and stitch together the story line within the fantastical and—on closer inspection—disturbing tableau. Influenced from an early age by Surrealism and folk tales, Hindsgavl mines our subconscious, delving into our dreams and buried desires in a wild roller-coaster of man versus beast. Marc Alberghina from France also employs clay and its historical associations to shed light on the human condition. Referencing religious and political upheaval throughout time, the artist addresses past transgressions and implores us to pay attention to the continuation of man's inhumanity to man.

Artists hold the potential to create works that unapologetically convey both involvement and detachment, self-expression and transcendence. Objects can bestow power beyond their immediate concern, becoming iconic when they emit shared stories. Works of art can reveal the reevaluation of commonly held values beyond the maker's expectation. Diverse backgrounds and disciplines aid in collectively confronting complex problems. Amid innumerable challenges and opportunities, artists create paths toward new discoveries, foreshadowing increased individual and collective stability. Although artists cannot solve all our social ills, they provide meaningful insights through their aesthetic journeys, elucidating what many cannot or will not acknowledge.

Makers mark the risks along the way, precariously traversing a creative tightrope on the path to self-knowledge. Their sensitivity to material infused with intellectual substance allows the figurative artist to become an effective communicator shedding light on our past, present, and future. The trajectory of their forward path is inexplicitly woven into their lives outside the studio. Although in a state of flux, often thrown off center, the artists reside in a fertile moment with a more humane future in their grasp.

Peter Held
Curator of Ceramics
Arizona State University Art Museum
Ceramics Research Center

Manifest Grace: Art, Presence, and Healing

IN AN INSIGHT that might be applied to any of the works of art in this extraordinary exhibition, Robert Irwin has spoken of the *physicality* of art, "a reduction of metaphor to get at [the] presence [that] is always there."

Created by a range of artists representing several nations and cultures, these works of profound physicality are saturated with presence. As viewers, we are confronted with sculptured images that assault the eye and impel us to engage the harrowing realities of persistent societal violence. These images, as spiritually overwhelming as they are aesthetically powerful, call us into the presence of chaos, the terrors of our own vulnerability, and the attendant costs to our individual and collective humanity. This is the message in figures such as Marc Alberghina's *Saint Sébastien B*: the singular self is inseparable from the world around it. The mute assertion throughout is that any search for self-designation is wedded to an understanding of the terminus of the self in human history. Thus these images demand a confrontation with truths at once timeless and startlingly immediate.

Two examples here force us to recognize that violence against women is as old as the world. In Michel Gouéry's *Riri* and *Fifi*, a pair of sculpted women seated formally with the classical stillness of Greek caryatids. Simultaneously, their frozen, empty faces and mutilated breasts are a silent assertion of their contemporaneity with the horrors we experience daily in films and television news. *J'accuse*. *Au secour*.

The terra incognita confronted by Teresa Gironès' *Víctima (Victim)*, she of the terrified eyes and sealed mouth, is more than a Jungian voyage toward individuation. The imposing portrayal of this victimized woman is, at its core, a cry for help. In its directness, the work conveys a piercing awareness of the need to assert individual power alongside individual powerlessness. The pain here gives concrete form to an insistent necessity to tell the truth; it is a call for healing.

Of course, artists in every century have worked from a vocation to expose truth to the light. In one stunning example, Laurent Esquerré's complex rendering *Le Calvaire (Calvary)*, 2010, accentuates the primacy of

questions of suffering and salvation. It is anchored in classical referents, in other eras when the human condition seemed fragile indeed, just as it does now. Still, these works are not eulogies. They ask Walt Whitman's enduring question "What stays with you latest and deepest? of curious panics, / of hard-fought engagements or sieges tremendous what deepest remains?" The assertion here is that art, as essential materiality wedded to a conceptual *ouvert d'esprit*, can be "what deepest remains," what engenders and ensures the continuing potential for transformation.

With reference to structures embedded in other histories and geographies, images created by the contemporary artists here erupt and fling themselves into our present-day consciousness. They do more than simply embrace the traditional role of the artist to edify, to give form to society's image of itself. This exhibition has the courage to engage the fundamentally transformational character of creative art making. Transformation, in this case especially, this *excavation* of the extraordinary from ordinary clay, carries within it the real possibility of new insight, of healing from brokenness. Artists like these, presenting us with their individual insight, guide our understanding of the larger collective realities that bind us.

The works here are impelled by the artists' desire to inform the public memory with the meanings of our individual lives and theirs, and of the mutuality of our habitation on this planet just now; they do not attempt to evade or to elude. Rather, in laying bare the roots of experience, they offer a glimpse of the mystery of human possibility. Perhaps there is grace in the glimpse, a mediation, a beginning.

I recently came across a timeless quote from this essay "The World as I See It" by Albert Einstein: "The most beautiful experience we can have is the mysterious.... [It is there] in true art.... Whoever does not know it ... his eyes are dimmed." The astonishing works in this exhibition allow us entry into a world of seeing, through undimmed eyes, and can lead us toward an affirmation of the power to change, to mediate, to heal both the perpetrators and the victims. That just may be what deepest remains.

Ronne Hartfield
Author, educator, and museum consultant

This Exhibition and Journeys in Native Art: A Personal Perspective

AS A NATIVE PERSON, the son of a distinguished Native artist, and Founding Director of the Smithsonian Institution's National Museum of the American Indian, my empathy with the art and the artists in this exhibition is immediate and profound. These artists depart without a backward glance from the academic conception of Western art as the individual genius speaking the universal. Theirs is a courageous visual protest through art—and a cry for communal response—in addressing society's frequent individual and collective brutality and inhumanity. Native American artists—and indigenous artists elsewhere—have walked at their peril this same thin line in Western art history for half a century. The intention of "art" in Native communities has different origins and purposes, not unlike Western European "art" prior to the Renaissance. It is an integral aspect of living on a daily basis and thus reflects life retrospectively and often, in aspiration, prospectively. The artist's intention and process in creating art are thus far more grounded in communal sensibility and experience than in pure individual artistic impulse.

Rick Hill, a Native artist and former museum director, explains the distinction as follows: "The main difference between Indian and non-Indian artists is that we are still community-driven. . . . Art is the cement that binds the Indian people together, uniting us with our ancestors and with generations yet to be born. Through art we can take a look at why language is important, why ritual is important, why land is important."

Bob Haozous, a brilliant contemporary Native sculptor and the son of the renowned artist Allan Houser, defines the essential nature of Indian "art objects": "I want to see people participating in my work. That's totally contrary to what we're taught in America—the artist as an individual, the genius. I don't want to see that in my work

at all. I'd rather see, at the most, a cultural reflection of being an Apache. I've been fighting those concepts of individualism, uniqueness, and universalism, concepts that are totally contrary to tribalism. Individualism denies a future or a past awareness. You claim it, you own it, but you're not part of it."

The affinity and intentionality of the artist, as well as the creative process that produces the art, are notable in this bold and striking exhibition, just as in Native sculptors such as Bob Haozous. "Protest art" created by gifted artists can be—and should be accepted as—great art by any legitimate aesthetic standard. But its communal origins, artistic motivations, and intended societal impacts differ from the academic nostrums of Western art history. The time has come, however, to put aside that distinction as being without difference when defining and measuring fine art and artistic achievement.

The distinguished cultural historian Jacki Thompson Rand, herself a citizen of the Choctaw Nation of Oklahoma, provides the eloquent conclusion: "[T]he Native artist . . . [values] the creation [of art] . . . over the final product. Process speaks to historical or cultural significance because it is testimony to cultural continuity and change. It is the evidence of lost traditions, innovations, preserved cultural knowledge, historic perspective, and vision of the future. . . . It takes into account a sort of 'spiritual evidence' that is integral to the creative process. The integrity of the creative process is foremost. The object is meaningless without it."

The *Body & Soul* artists reflect the communal experience of immigration, prejudice, hostility, outcast status, violence, and abuse. Although separated by time, space, and cultural experience, Native artists and their courageous brothers and sisters in this exhibition are bold fellow travelers along creative paths differently chosen but profoundly compelling as great art.

W. Richard West Jr.
President and Chief Executive Officer,
Autry National Center of the American West
Founding Director and Director Emeritus,
National Museum of the American Indian

The French Connection

AS COMMITTED FRANCOPHILES, we welcomed the challenging opportunity to arrange and lead a study tour to the south of France in 2002 for a group of collectors from the Renwick Museum in Washington, D.C. Although we planned to explore a range of craft media, it became apparent that contemporary French ceramics had achieved a unique position in the arts, both locally and internationally. It was impossible to visit the ceramic culture in this area without becoming aware of the Picasso legacy. At the Picasso Museum in Antibes, a transformed Grimaldi Castle, the artist's paintings and ceramics live brilliantly together. It has been suggested that contemporary ceramics began in 1946 when Picasso came to the town of Vallauris. Working with local potters, he began to transform traditional forms of dinnerware into sculptural statements in which paint and clay were artfully merged. Although other artists were experimenting with similar ideas, Picasso's reputation and high visibility had a great impact on the development of contemporary ceramics on the world scene. His presence drew many other famous French artists to the area at this time, including Miró, Léger, and Cocteau, all of whom revisited the medium of clay and provided a context for our study of contemporary French ceramics.

As we began to experience the creativity and diversity of this medium, it became clear why Picasso had sought refuge near Antibes after World War II and why his work in paint and clay flourished. The historically rich landscape, the company of committed artisans, and the welcoming colors of the land and sea were certainly seductive and inspirational for him. Likewise, our visits to the artists' studios there revealed a seamless continuum of terrain, work, and lifestyle that appeared to provide nourishment and direction. This sense of place became an intimate and enduring experience for our group when we visited the hillside house and studio of Daphné Corregan and Gilles Suffren, who had invited twelve prominent French ceramists to show their work at a "galerie sous le ciel." The artists installed their vibrant works on the terraced ridges adjoining the house, and the result was a magical fusion of the art, the artists, and the French countryside. Many of these ceramists were among those who had been invited to participate in or conduct workshops in Korea, China, Australia, and several countries in Africa. In turn, a number of important ceramists from Japan, England, and the United States have worked or settled in France and have inspired the work of their host country. Through these cultural exchanges, French ceramists have become attuned to the developments in the international art scene.

A decade has passed since our memorable study trip to the south of France and our introduction to contemporary French ceramics. It has been gratifying to observe that the sense of place that nurtured the French ceramists has not led to an insular existence but rather to an ever-expanding vision and a willingness to embrace the important issues of the day.

Karen and Michael Rotenberg
Collectors

Catalogue

IN A WORLD consumed by greed, Marc Alberghina questions identity in an unusual and metonymic approach in which his hometown, Vallauris, becomes a case study and epitomizes the fall of post-industrial cities. The **artist** confesses: "I bear the history of Vallauris as my own disease." By way of cure, he revisits icons and themes from the history of art, such as *vanitas*, the bust, or the martyrdom of Saint Sebastien.

Vanitas is at the core of Alberghina's works. Like many other artists since the 1990s, he reinterprets them by means of alteration and grotesquerie. Since the nineteenth century, workshops and manufactories have become the new cathedrals, and money is now the only value. Alberghina's works stress the same shift from an eschatological to a social meaning. He asks us to pay attention not only to our finitude but also to the end of an era. "Bystander, don't turn a blind eye. I was what you are, and you will be what I am."

In 2011 Alberghina readdressed the bust as an icon of Western societies in a series of uncanny self-portraits that hint at the dissolution of his own self in Vallauris conservatism. The faces are hidden and the hearts are emphasized with this very typical and gaudy glaze of 1950s Vallauris.

More recently, Alberghina has tackled an icon from the history of art. His *Saint Sebastien* alludes to a classic Balzacian paradox of scenes from provincial life, where all passions, dreams, and desires thrive, but which is also full of rumors, intolerance, and banter. Alberghina features himself as a martyr three times in a redemptive fight to vindicate his own vision of the world. Is this not reminiscent of Adoniram from Nerval's *Journey to the Orient*, in which that talented builder is assassinated by his three treacherous companions, talentless laborers motivated by envy and greed? Alberghina sees himself as Saint Sebastien, condemned by his peers and thrown into the Roman sewage system known as Cloaca Maxima. Thanks to this scapegoat, it's the unity of a society that can materialize, overwhelmed by the violence of its mimetic desires.

Laurent de Verneuil

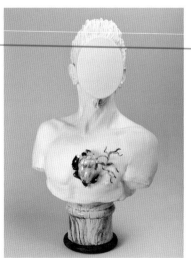 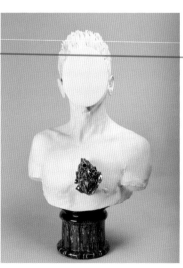 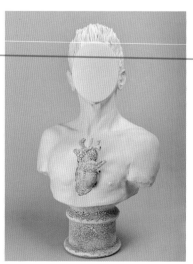

Marc Alberghina (French, b. 1959)

Left to right:

Autoportrait A (Self-portrait A), 2011
Earthenware, enamel
27 5/8 x 19 3/4 x 11 3/4 in.
(70 x 50 x 30 cm)
Courtesy of the artist

Autoportrait B (Self-portrait B)
(detail opposite), 2011
Earthenware, enamel
27 5/8 x 19 3/4 x 11 3/4 in.
(70 x 50 x 30 cm)
Courtesy of the artist

Autoportrait C (Self-portrait C), 2011
Earthenware, enamel
27 5/8 x 19 3/4 x 11 3/4 in.
(70 x 50 x 30 cm)
Courtesy of the artist

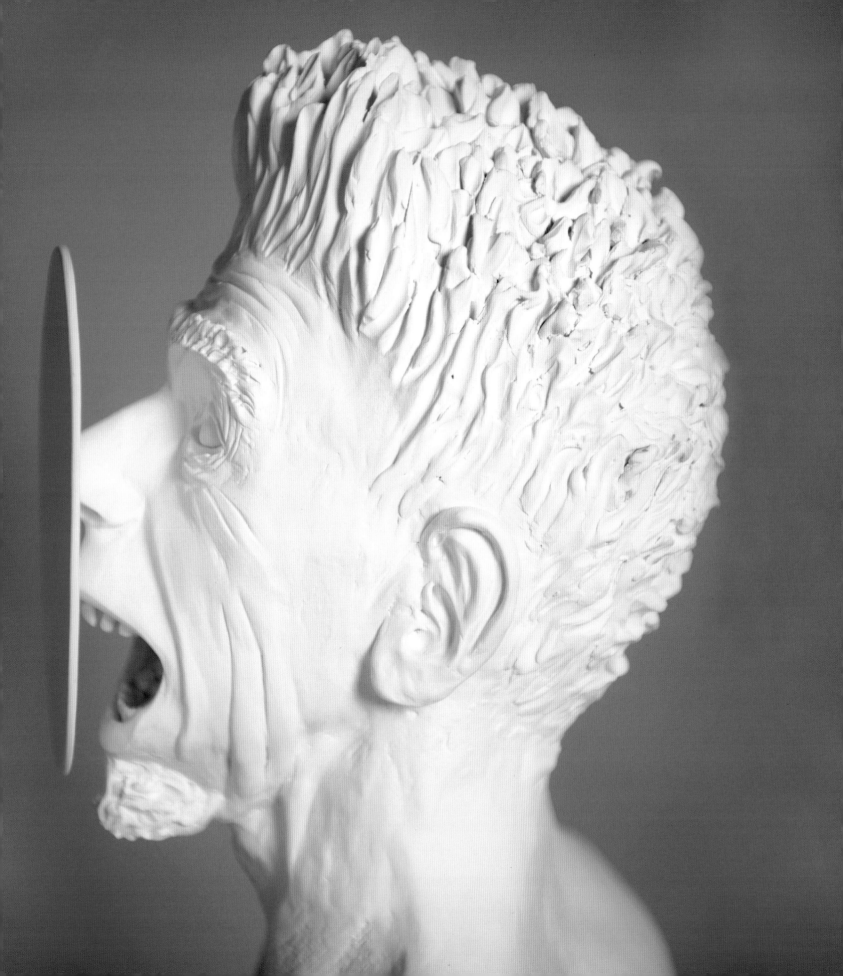

Marc Alberghina

Opposite:
Saint Sébastien B, 2012
Earthenware, enamel
66 ⅞ x 23 ⅝ x 15 ¾ in.
(170 x 60 x 40 cm)
Courtesy of the artist

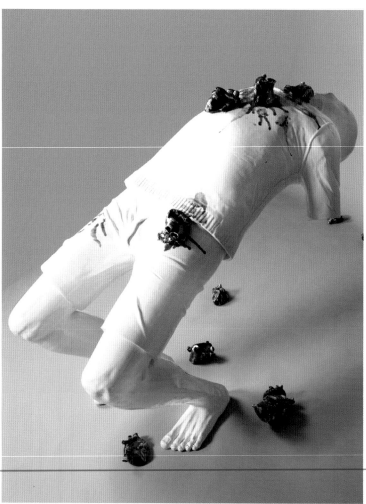

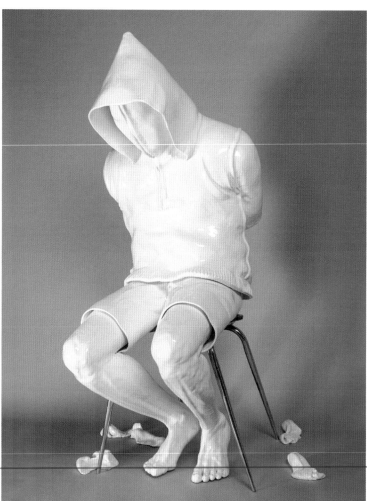

Marc Alberghina

Saint Sébastien A, 2011–12
Earthenware, enamel
31 ½ x 55 ⅛ x 23 ⅝ in.
(80 x 140 x 60 cm)
Courtesy of the artist

Marc Alberghina

Saint Sébastien C, 2012
Earthenware, enamel
43 ⅞ x 16 ⅞ x 27 ⅝ in.
(110 x 43 x 70 cm)
Courtesy of the artist

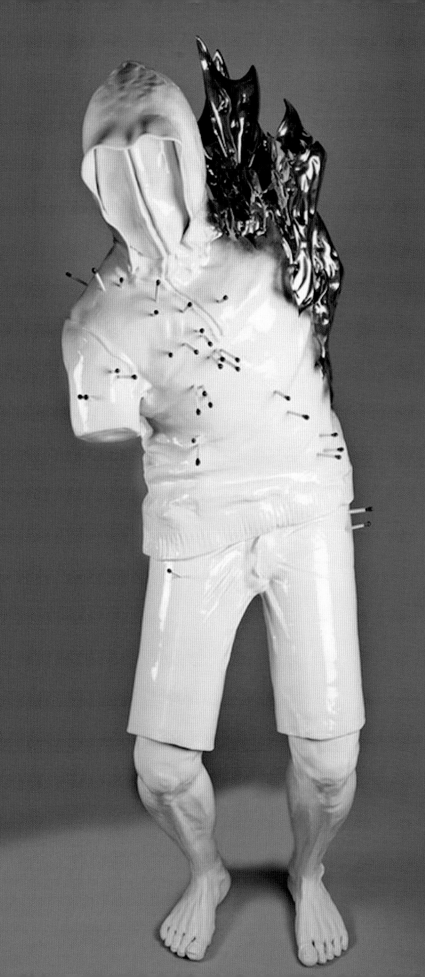

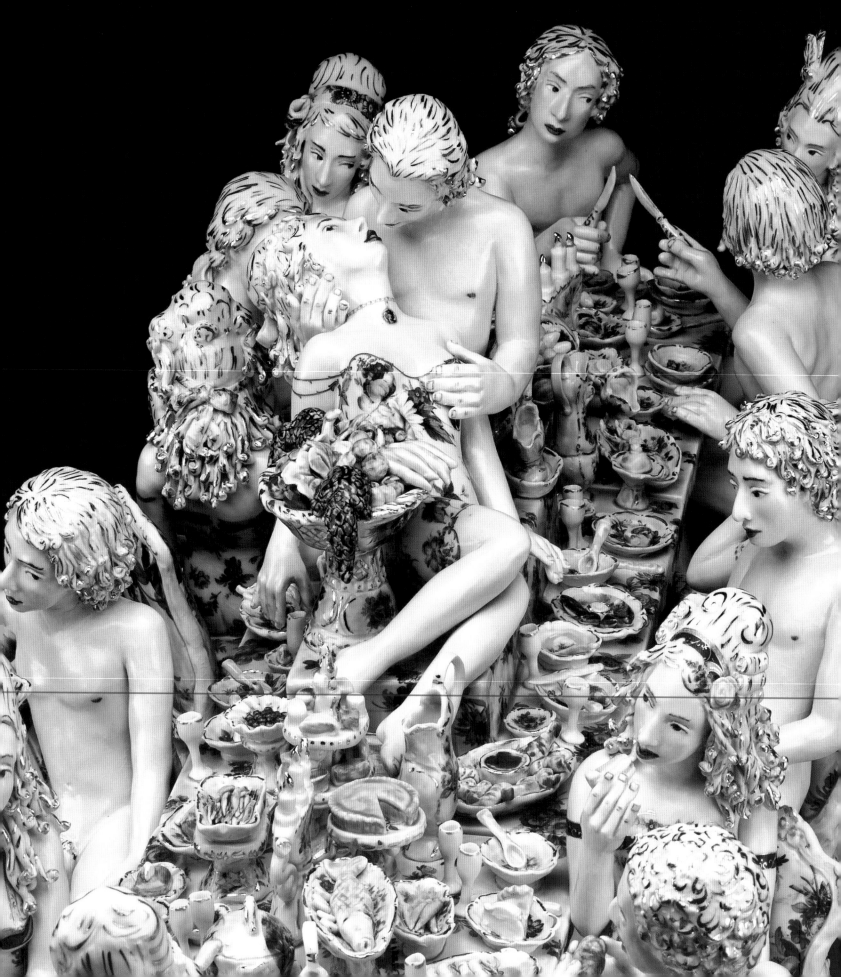

PLATE BY PLATE, porcelain became the privileged dinnerware of the eighteenth-century aristocracy and *haute bourgeoisie*, and the collecting of porcelain thus began its meteoric rise toward obsession. Porcelain's dominance was evidenced by the growing number of factories that flourished in Europe. One of the most important changes brought about in this prized material was the replacement of the beloved sugar figurine with the porcelain figurine. Much like fashion houses, porcelain factories created their own forms, designs, patterns, and ornaments, and the bourgeoisie also used the dinnerware in placing, or patterning, their dinner parties. The interpersonal dramas of such parties, the fashion and the fuss, continue today, and they make their way into my work.

My primary focus is liberating the figurine from its roots in mass production by creating one-of-a-kind autobiographical narratives. As ornaments, collectible objects of wealth, and artifacts of the domestic realm, decorative figurines conceal secrets about individual lives. Inspired by these hidden stories, I transform the base figure by layering images and ornament and playing with forms to construct my own tales and reveal my own observations.

Currently I am expanding upon my previous parodies of decorative figurines by delving into the darker side of relationships and domestic rites: twisted tales of master and servant; the innocence of the floral-clad maid; the dominance of patriarchal desire. Tricked out in frilly camouflage, these characters disregard tradition and expose society's cistern of unmentionables.

Perhaps this is "seeing the unseen"—as a guest at a dinner party observes the other guests, wistfully and possibly (and hopefully) fantasizing!

C. A.

Chris Antemann (American, b. 1970)
in collaboration with **Kendrick Moholt**

Feast of Impropriety, 2011
Archival paper, ink
60 x 40 in. (152.4 x 101.6 cm)
Courtesy of the artists

Chris Antemann

Lust & Gluttony (detail opposite), 2008
Porcelain
10 ¾ x 25 ¾ x 11 ½ in.
(27.3 x 65.4 x 29.2 cm)
Museum of Arts and Design
purchase with funds provided by
Nanette L. Laitman, 2008

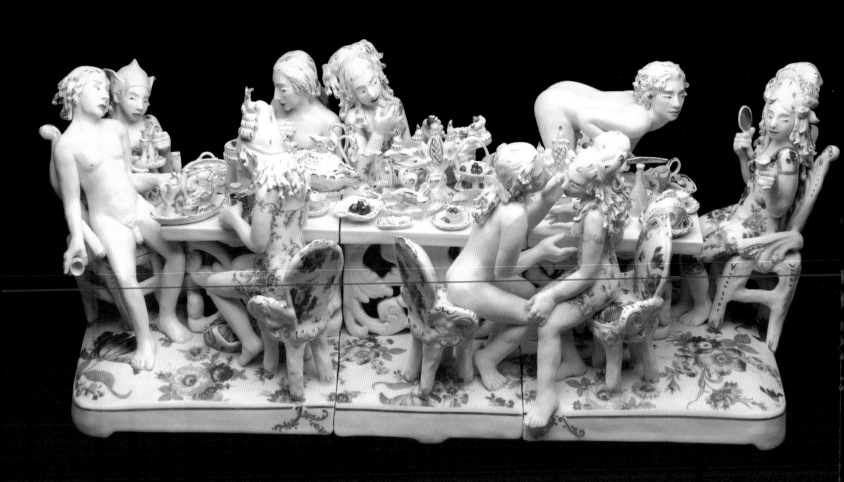

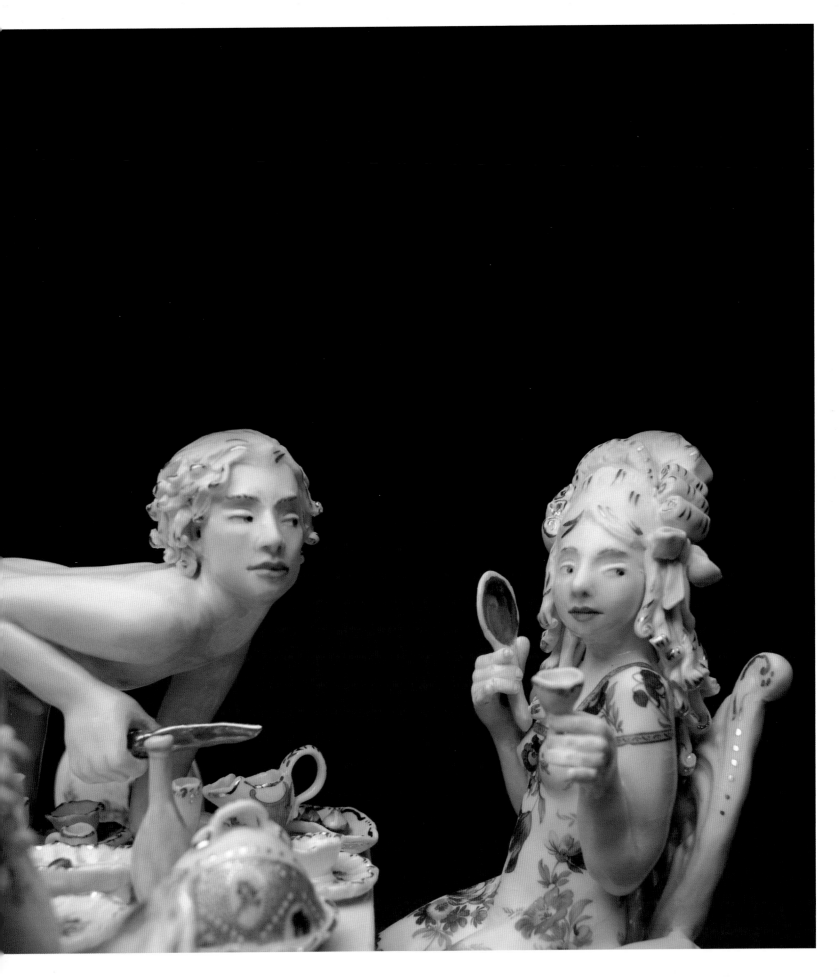

THE FIRST WORD that comes to mind when I think of the work of Damien Cabanes is "solitude." The solitude of his work, in its times, which, whatever the tendencies or fashions, asserts its own exigency, its necessity. Cabanes is not isolated; he is at the heart of events in international art and dialogues with artists in every generation, however close or remote their relation to his own concerns. He is not isolated, he is alone. In its development, his work never compromises with the aesthetic fashions that we seem to be expected to take on board. Rather, it tirelessly explores the pictorial and sculptural territories conducive to its subject, whatever they may be. His art seeks to constitute these so that it can appear and unfold in a presence that is alive with surprises and enigmas. This subject is not easy to define. We could say, to sum it up as comprehensively as possible, that it is "a purportedly complete human thing" and, for that reason, "infallibly faulty."

Cabanes' disposition keeps him on the edge of the zones of turbulence and noise. He is able to maintain a position in a zone of relative calm which enables him to escape the general temporality. As philosopher Alain Badiou says, "courage is always the courage to slow down, not to accelerate; it is not the courage of speed unleashed, it is the courage of slowing down, of a stretched temporality. And consequently, it is the courage of a certain indifference to fallacious novelty. And this is not as easy as all that, because fallacious novelty is what is proposed to us, immediately, as the only thing in life that matters."

For more than thirty years now, Cabanes has been creating a terrain that may sometimes evoke others but is uniquely his own. Forging doggedly ahead, in each work he experiences human nature, and the nature of things, which exist only in the manifestation of an unstable substance made up of weakness, defection and disappointment. For more than thirty years now, Cabanes has been sharing his silent revolution.

Olivier Kaeppelin
(excerpts from "Une part de ce qui arrive maintenant" [2011], translated by Charles Penwarden)

Damien Cabanes (French, b. 1959)

Sarah en Robe Bleue, 2006
Ceramic, paint
18 ½ x 23 ⅝ x 19 ⅝ in.
(47 x 60 x 49.8 cm)
Courtesy of Eileen S. Kaminsky
Family Foundation

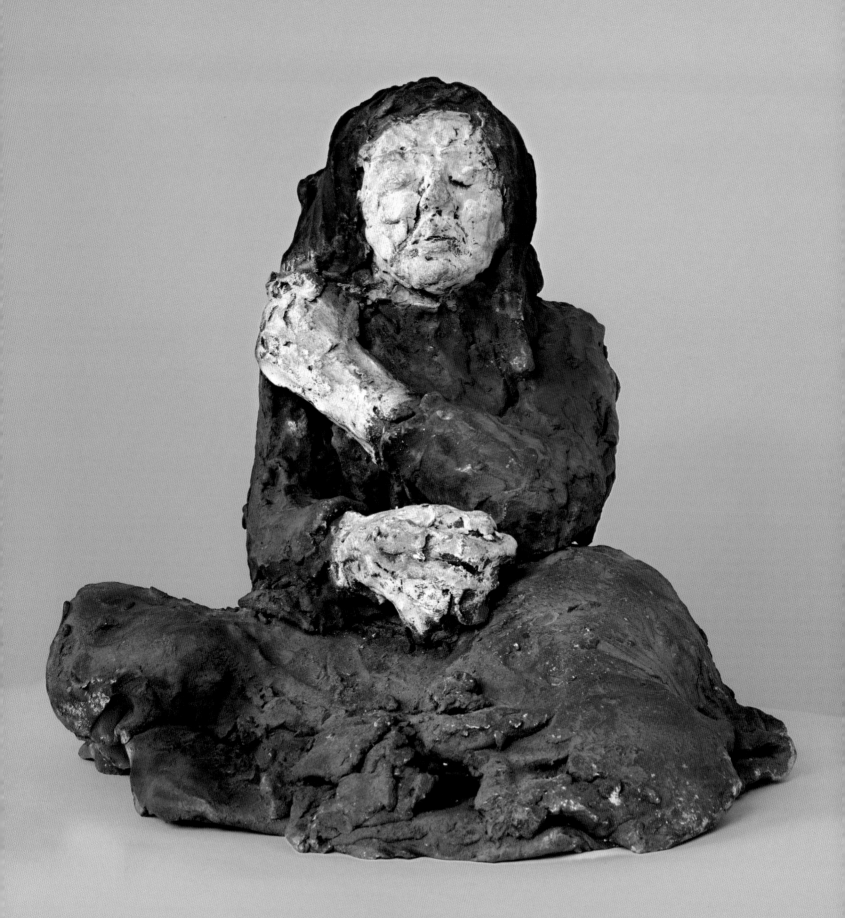

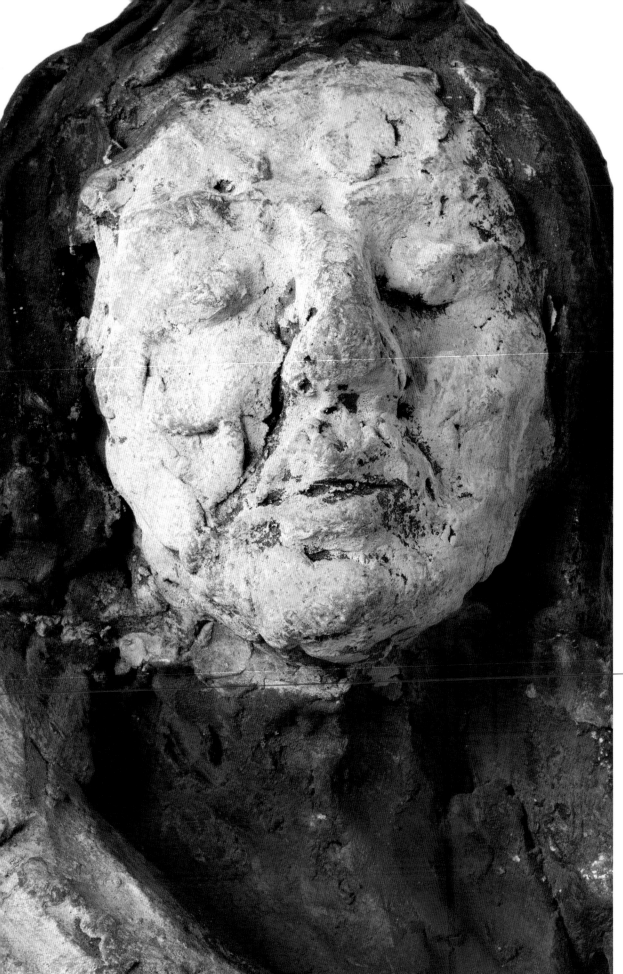

Damien Cabanes

Sarah en Robe Bleue (detail)
(*Sarah in a Blue Dress*), 2006
Ceramic, paint
18 ½ x 23 ⅝ x 19 ⅝ in.
(47 x 60 x 49.8 cm)
Courtesy of Eileen S. Kaminsky
Family Foundation

Damien Cabanes

Opposite:
Gina with Blue Dress, 2006
Oil on canvas
68 ½ x 69 in. (174 x 175.3 cm)
Courtesy of Eileen S. Kaminsky
Family Foundation

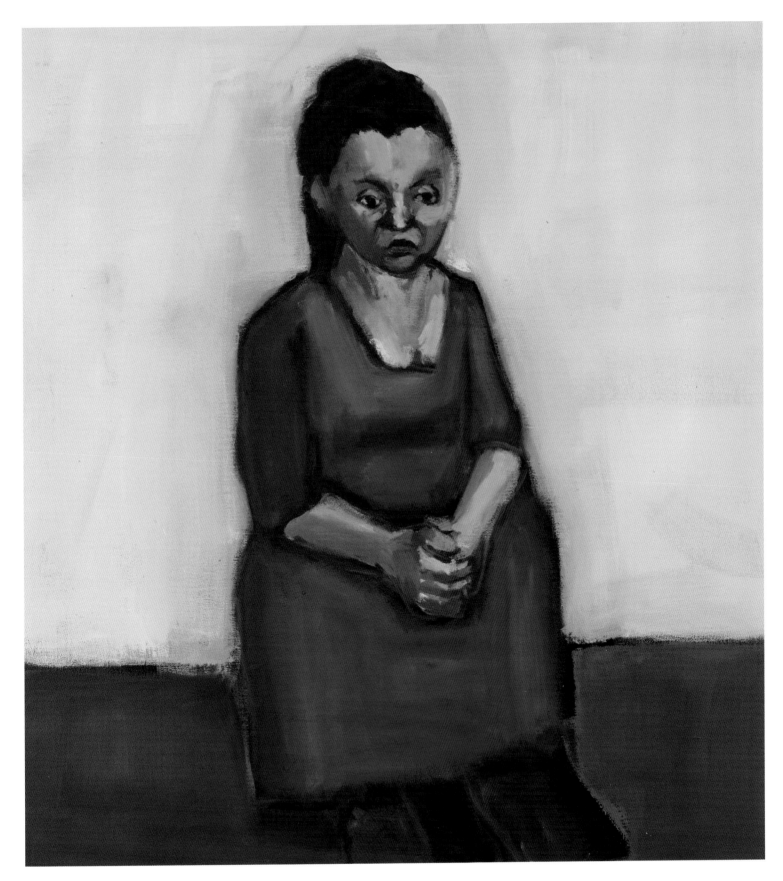

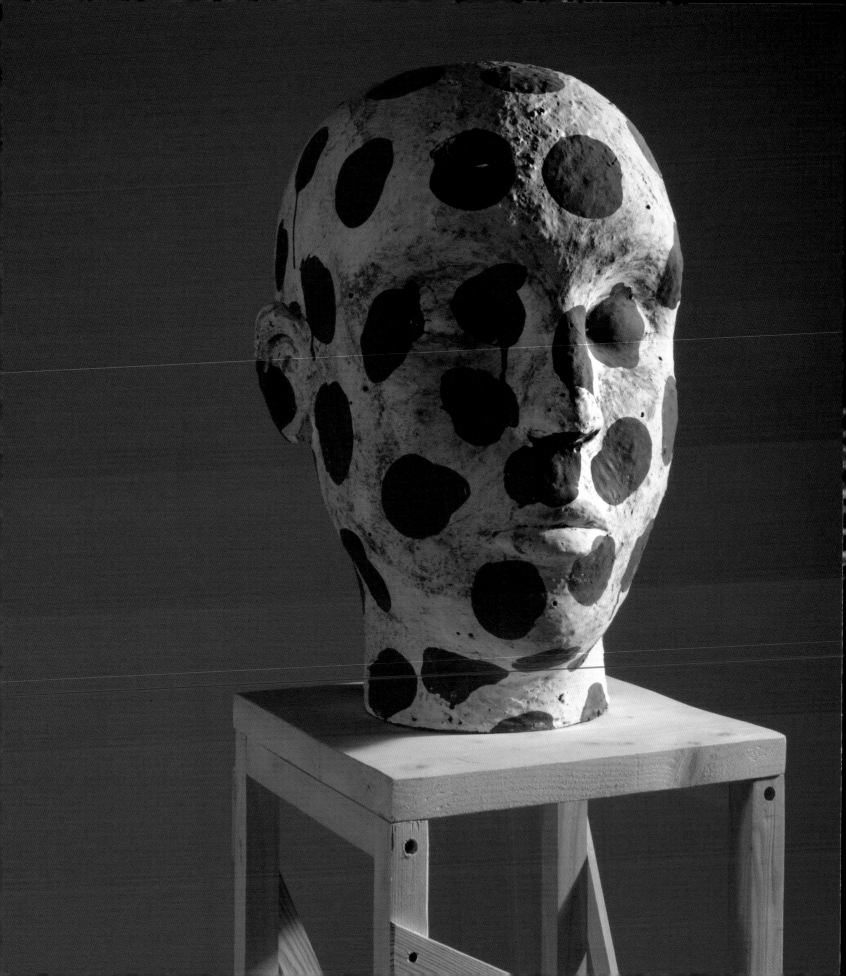

THE BODY—or parts of the body—have appeared in my work consistently over the last thirty years, most often sparked by a political event or a more personal upheaval. During the Rwanda and Bosnian tragedies, my *Standing Figures* proudly showed their wounds and nakedness.

In 2001 I began a long series of abstract skulls, in all sizes and clays, melding my engagement with both sculpture and the decorative arts. The skulls began as an immediate reaction to my mother's death, followed by an extensive exploration of the shape, using different ways of building, firing, and using space: the skull serves simultaneously as an envelope, a shape, a vessel.

The new series of painted faces has more to do with a blatant reference to the force of primitive cultures, or perhaps to an overwhelming state of despondency over the ridiculousness of the conditions of our world today. I'm more interested in revealing emotions—feeling, guessing, supposing, sharing—than in telling stories.

No material other than clay would suit my way of working, particularly with the more figurative work. My recent heads are modeled in a very similar way to earthen architecture, the surfaces smoothed and defined by the pressure of my fingertips. The whole process of the *making* and the labor entailed are important for me and for the outcome of the work. The faces have been spontaneously painted or smeared with colored engobes, or slip, erasing or dulling a good part of that operation, hopefully putting the accent more on the whole than on an expression. Their precarious constructed bases, such as scaffolding, place the heads at a height so that we are obliged to receive them straightforwardly, their size dominating. Hopefully, these combined details will contribute to the boldness and reference a more humble and crude sculpture that I am searching for here.

D. C.

Daphné Corregan (American/French, b. 1954)

Painted Face, 2012
Terracotta
22 ¾ x 16 ⅜ x 18 ⅝ in.
(58 x 41.5 x 47.5 cm)
Courtesy of the artist

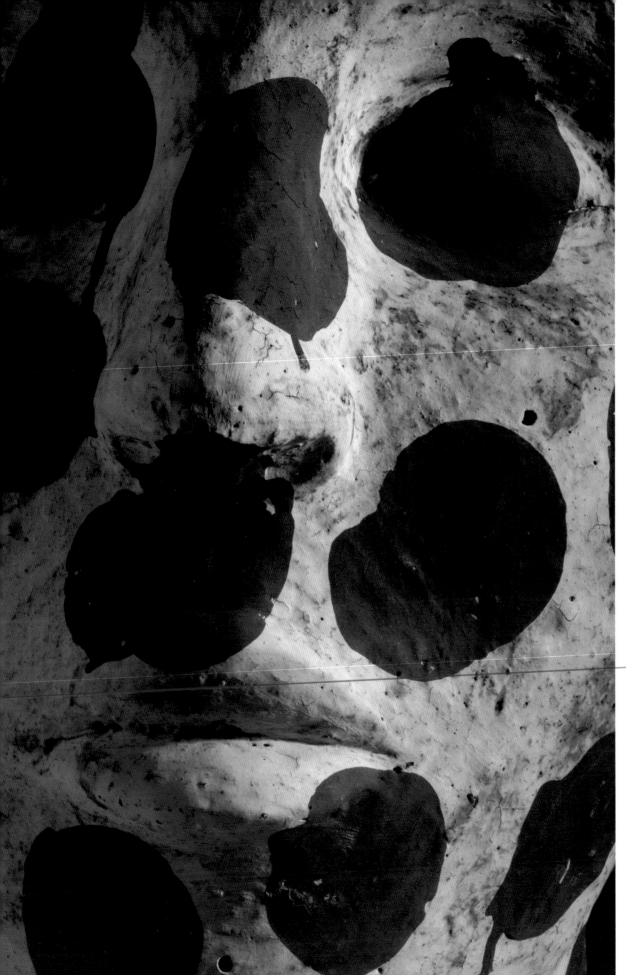

Daphné Corregan

Painted Face (detail), 2012
Courtesy of the artist

Daphné Corregan

Opposite:
Smeared Face, 2012
Terracotta
26 3/8 x 15 3/4 x 16 7/8 in.
(67 x 40 x 43 cm)
Courtesy of the artist

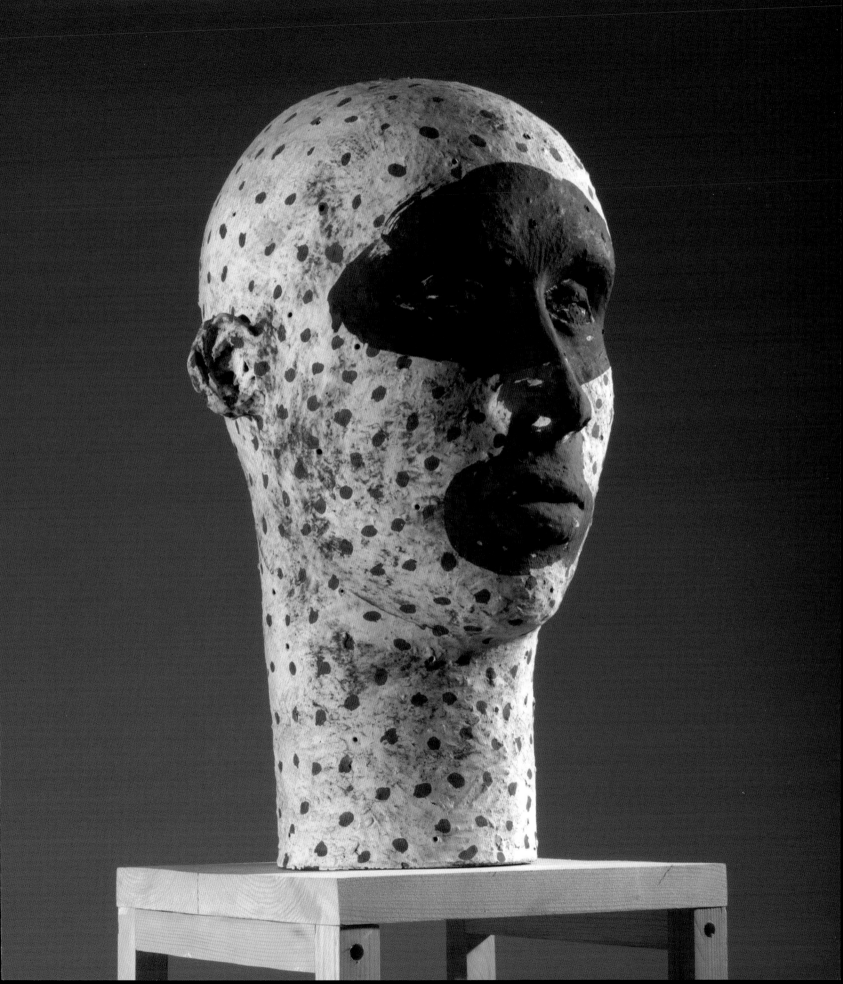

THE VIDEO PERFORMANCE *Corps au Travail* (*Body of Work*) takes as its starting point two series of self-portrait photographs: *Femme Sauvage* (*Wild Woman*), 2000, and *Danse des Cheveux* (*Hair Dance*), 2009. Working with the physicality of clay, I came to the idea of building an open space, covered with clay, at the level of my body, like "a room of one's own," where the raw clay could record the impact of my body and hair in motion. With support from the Cité de la Céramique à Sèvres, I realized the project *Chambre d'Argile* (*Chamber of Clay*) and the video performance *Corps au Travail*, in which the presence of the physical body in its nakedness and truth came to me. It is the body that speaks spontaneously. When entering this malleable space, I used my body as a tool, an implement.

This work fits into the theme of the exhibition *Body & Soul*, as it incorporates moments of doubt and assurance, control and affection, play and nonsense in the material, yet without knowing what the final result might be.

Body of Work is a form of rite of passage, where I experiment, doubt, and play. This frees me. This is the story of everyone, the human in his or her absurdity and the desire to escape: a celebration of the individual human will. To paraphrase the filmmaker Robert Bresson "I compel myself not to think, but to act spontaneously."

V. D.

Valérie Delarue (French, b. 1965)

Stills from *Corps au Travail*
(*Body of Work*), 2010
Video
20 minutes
© 2013 Artists Rights Society (ARS),
New York / ADAGP, Paris

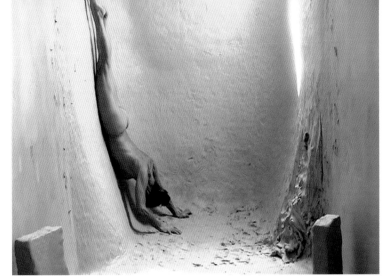
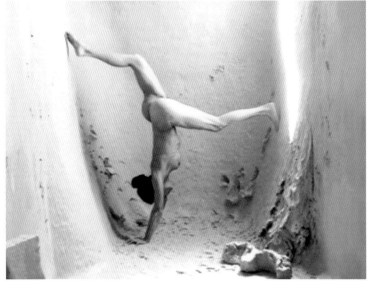
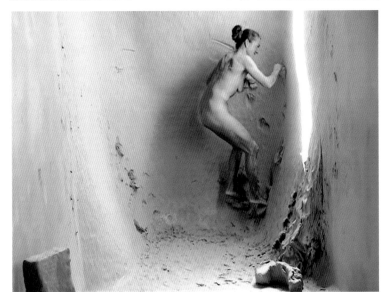
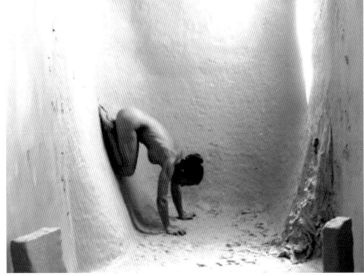
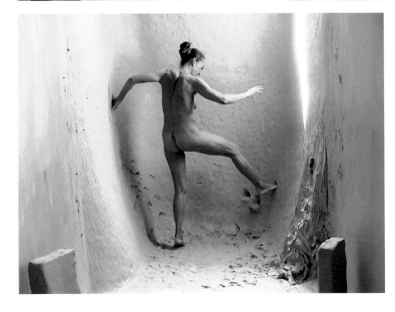
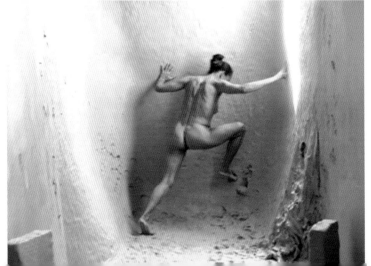

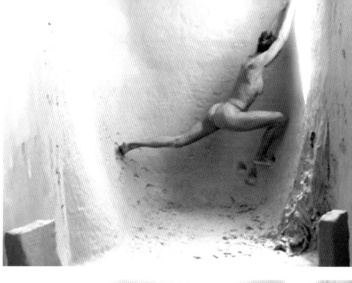

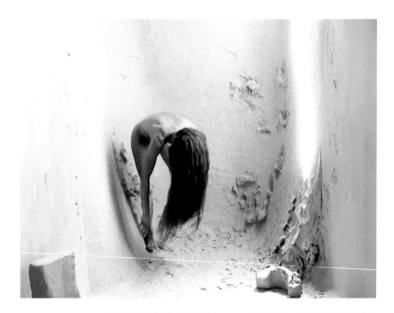

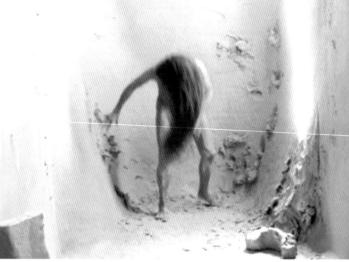

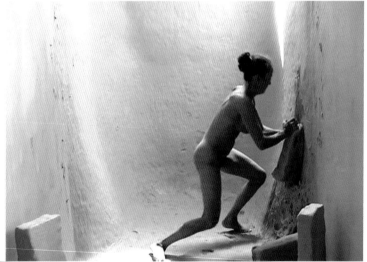

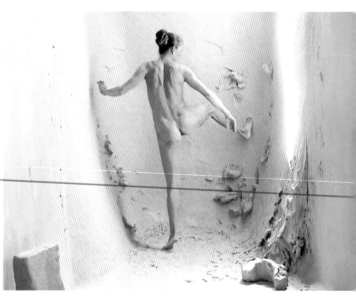

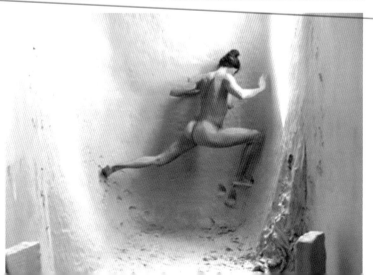

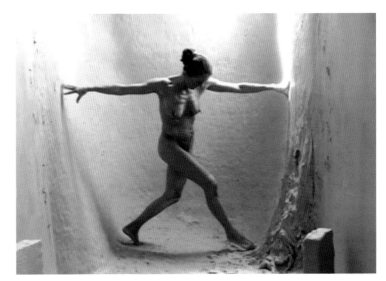

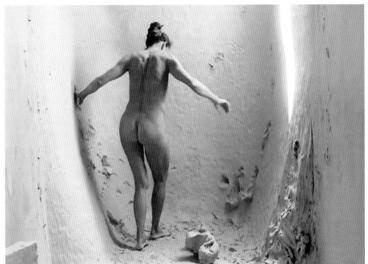

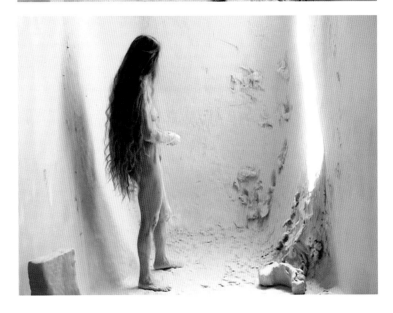

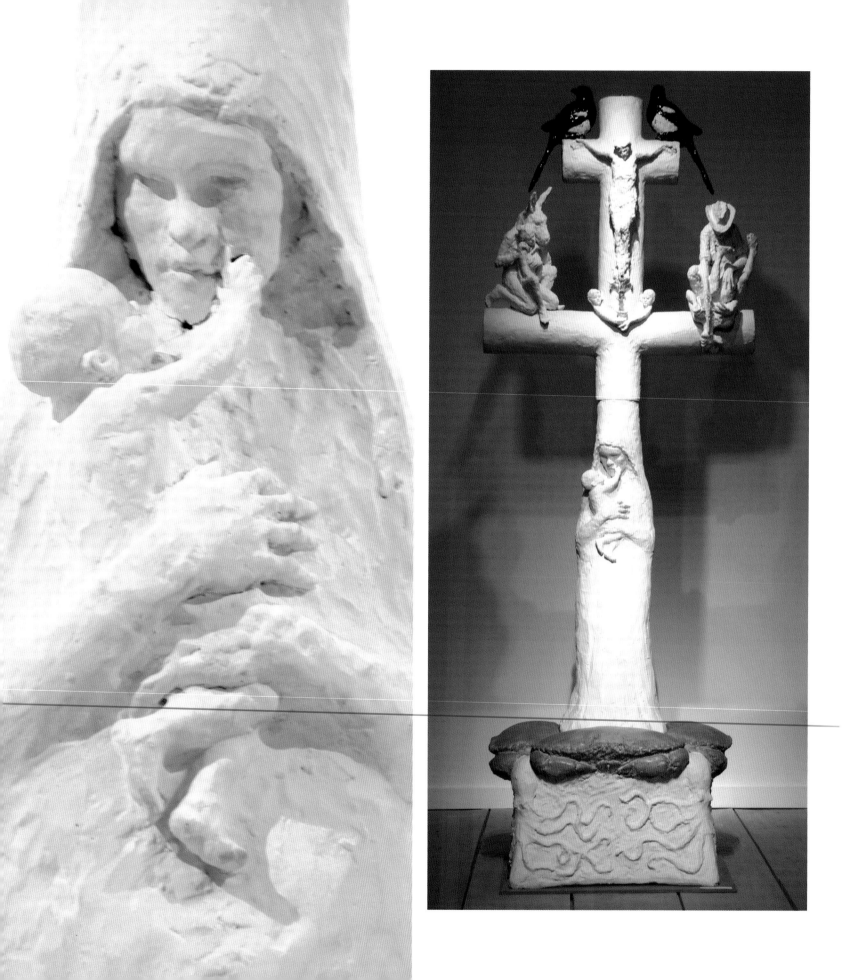

HOW DO WE relate the physical and artistic relationship of Laurent Esquerré to the images he sees in the world around him? Fascinated by mythology, intoxicated by tales and legends, he makes paintings and drawings as part of a tradition of symbolist and figurative subjects that take us on journeys through his emotions and his childhood memories. Many works are "snapshots," pretexts for romantic reconstructions of stories filled with passions, fantasies, fears, and ritualized pleasures.

At the same time, it was the discovery of the traditional techniques of his native region that inspired the artist to model sculptures in the workshops of the family pottery, Nots Frères. Since then the ceramic medium has continued to be a significant part of his work. He uses the material and techniques to live what he calls "my time of clay."

In his natural and spontaneous mode of thought, his favorite themes also invest his sculpture. His figural works are pretexts to represent chimerical associations and unusual images. In these works, animals can be mirror images of human beings, even human beings of monstrous power. Mysterious chimeras and composite figures inhabit the production of the artist.

The dreamlike universe of Laurent Esquerré has managed to express his fantasies or unconscious fears of our world. The artist is able to make the ceramic medium a means to renew the imaginary.

Julie Marzat
(translated by Franck De Grandidier)

Le Calvaire (Calvary) is a response to the prevalence of Christian crosses throughout Brittany, where I have traveled often. For me, it is a structure that reflects the conflict between good and evil. In my work, I struggle with the tension between good and bad, love and sex. The cowboy on the cross shooting the devil is an obvious internal battle doomed to failure because one cannot kill the devil. The magpies, intelligent birds known as chatterboxes, have been maligned in Christian legend; believed to have been witnesses to the crucifixion of Jesus, they showed no emotion. By contrast, the dove, also present, shed a tear. The donkey and the woman reference love and sex in Shakespeare's *Midsummer Night's Dream* through the vehicles of Tatiana and Nick Bottom. The crabs at the foot of the cross offer protection, but the key figures are the mother and child, who represent the essence of life.

L. E.
(based on curators' interview with the artist in 2012)

Laurent Esquerré (French, b. 1967)

Opposite:
Le Calvaire (Calvary) (detail left), 2010
Earthenware
88 ⅝ x 31 ½ x 29 ½ in.
(225 x 80 x 75 cm)
Courtesy of the artist

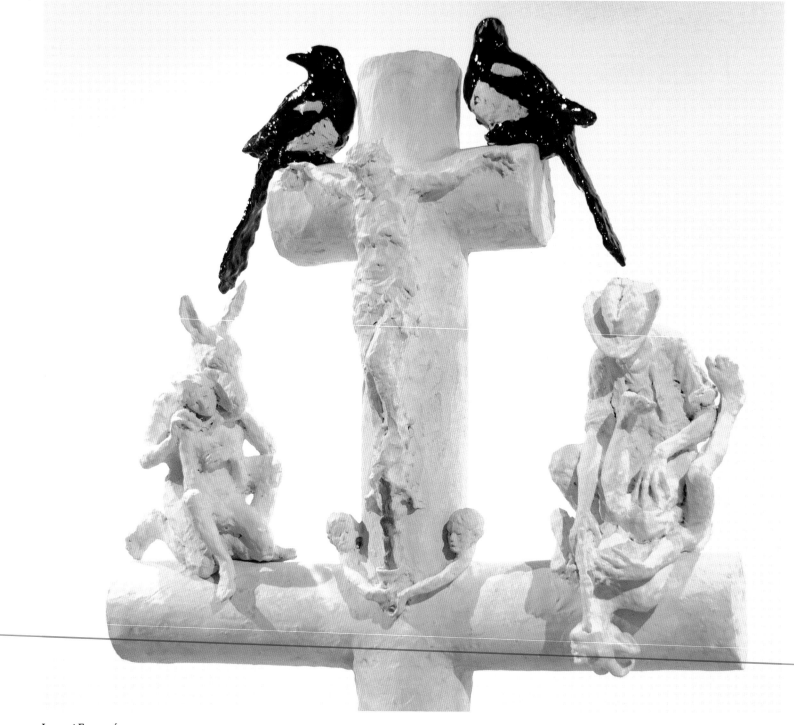

Laurent Esquerré

Le Calvaire (*Calvary*) (detail), 2010
Courtesy of the artist

Laurent Esquerré

Opposite:
La Jeune Fille à la Barque
(*The Young Girl on the Barge*), 2012
Lead pencil on paper
78 ¾ x 59 ⅛ in.
(200 x 150 cm)
Courtesy of the artist

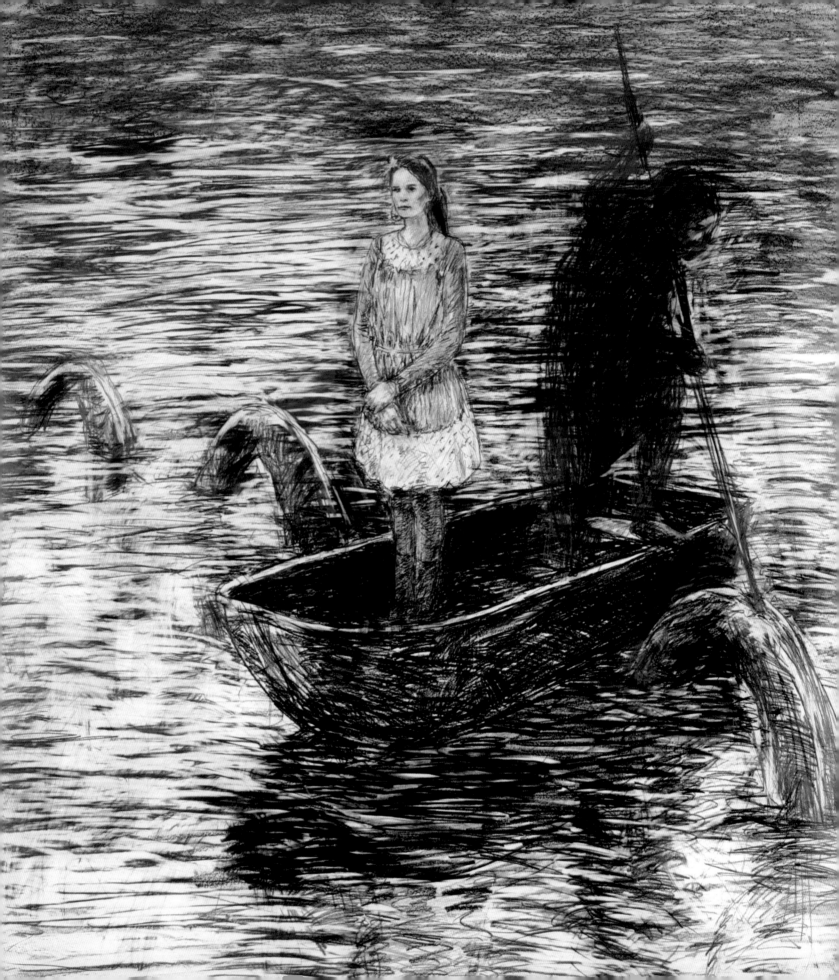

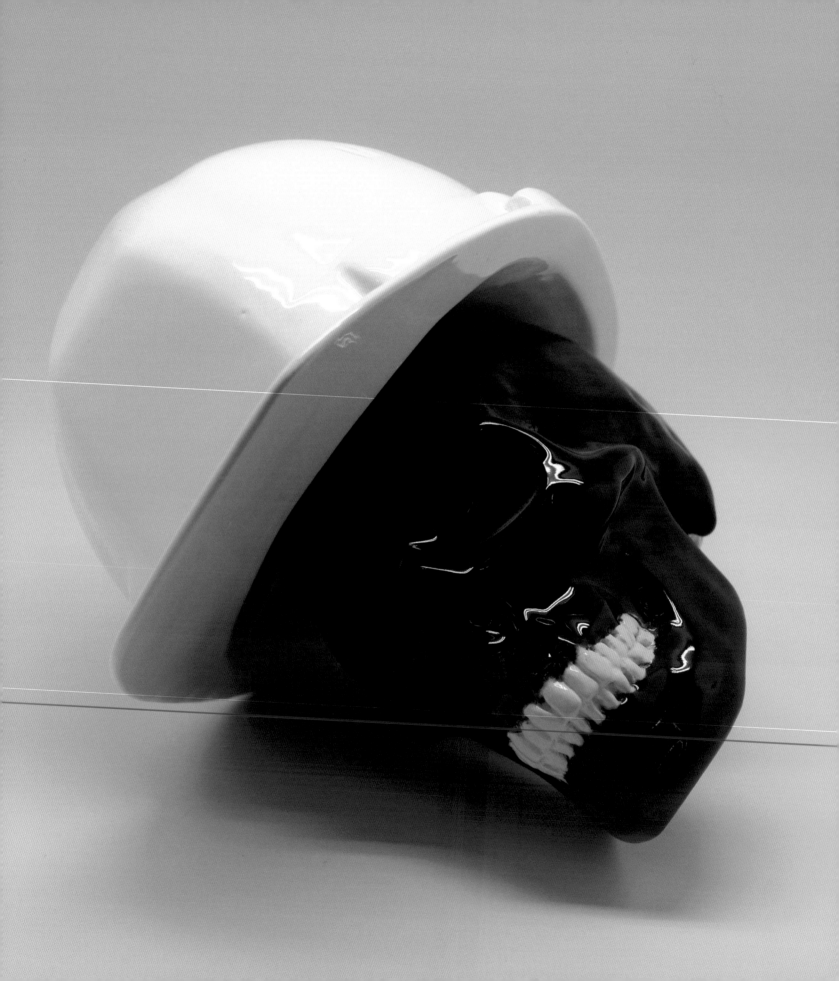



MY WORK DEVELOPS according to a rhizomatic system of values, where the inscription is like a network of connections.

Because of my critical view of contemporary realities and illusions, I believe that the only way to approach my work is in the context of complexities and of confusion. My work creates more interpretations in the semantic layers that connect all the areas of thinking to one another. I am engaged in both the aesthetic and the formal, the political and the sociological, the economic and the ethical, the metaphysical and the religious. VHS, antenna cables, protective helmets: these technical materials are transformed and re-created into plastic vocabulary.

I let my works function as failing strategies. They are harmless objects, changed into critical bombs directed toward the mechanisms that guide our relationship to the world. I confront individual ideologies, contemporary architecture or economics, politics or modernity, as a part of the fascination with the invisible. While they comprise moments of art history, they also question the transference of knowledge, the suggestive power of pictures, the seduction of violence, and the critical power of deconstruction, utopias as well as the influence of history or architecture on individual lives.

We are witnessing a permanent state of insecurity, where every certainty can be deconstructed and where there is neither center nor transcendence. Through this vision of basic human imperfection, the need to fight, to dialogue, and to get engaged is confirmed. My work is an eternally conscious action and reaction to all forms of determinism, totalitarianism, and every attempt at breaking down individualism. To exist is to oppose, since life is basically subversive power.

Regarding *Forget*, I used ceramic in this piece mainly because of its fragile nature. A helmet that is meant to protect us becomes fragile, breakable, vulnerable—this shows the fragility of our brain, thoughts, and even the idea of work. I do not often work figuratively. But this project, despite the obvious figuration, is rather about the idea of work, physical labor, which can be extremely hard, demanding, and underpaid, as well as looking at work that is about thought, reflection—using the brain rather than the body. Today's society is against fragility. It's about being strong, fast—about performance. We are often slaves of work—whether physical or not—there is even a saying about working ourselves to death.

When the majority of theories, systems, and ideological structures with which the contemporary world has been constructed are in crisis, what must be clung to and what must be completely forgotten? I wanted to show that both the body and brain are fragile.

M. F.

Mounir Fatmi (Moroccan/French b. 1970)

Forget, 2010
Porcelain
4 ⅝ x 12 ⅝ x 9 ½ in.
(11.9 x 32 x 24.1 cm), each
Courtesy of the artist; Goodman Gallery,
Johannesburg, Cape Town

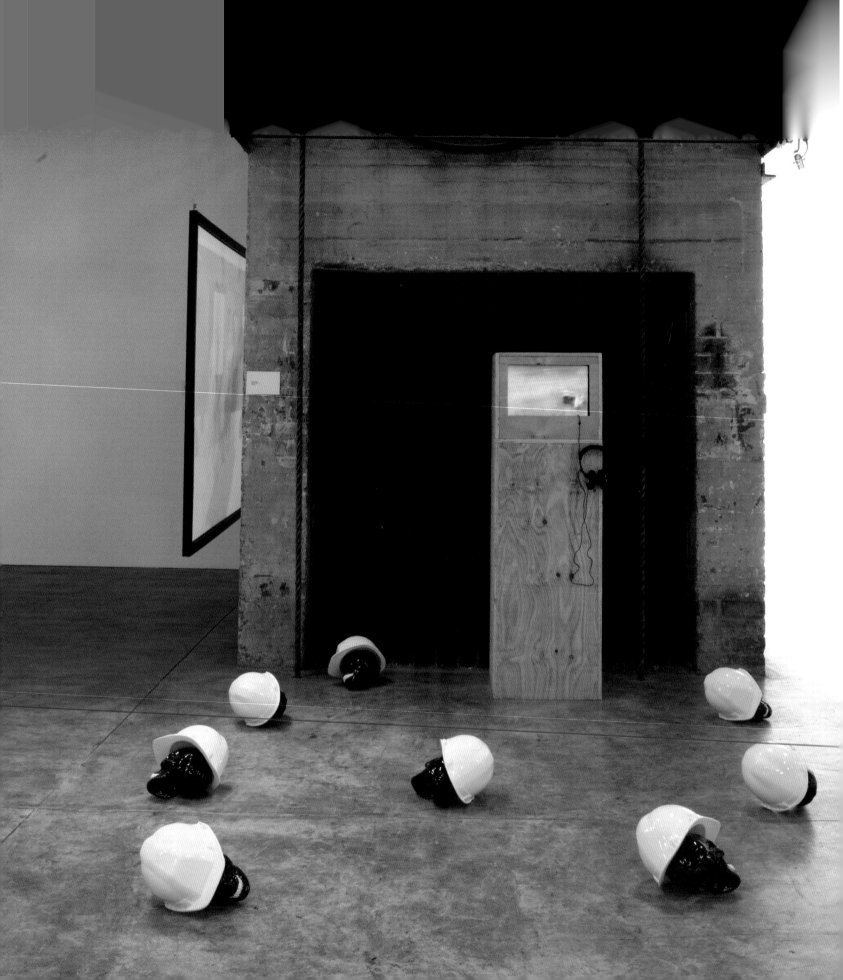

Mounir Fatmi

Forget (installation view), 2010
Courtesy of the artist; Goodman Gallery,
Johannesburg, Cape Town

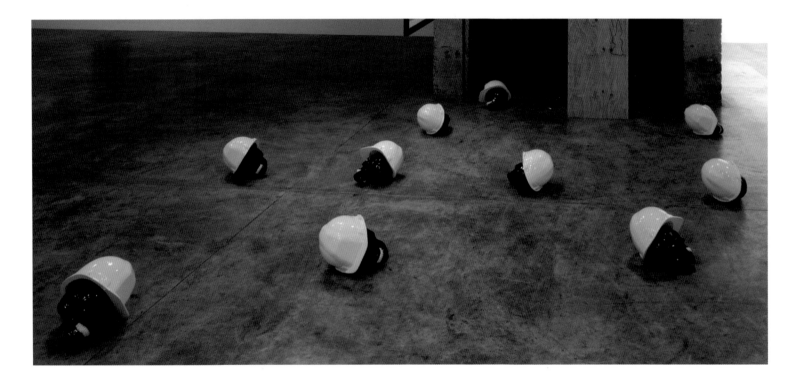

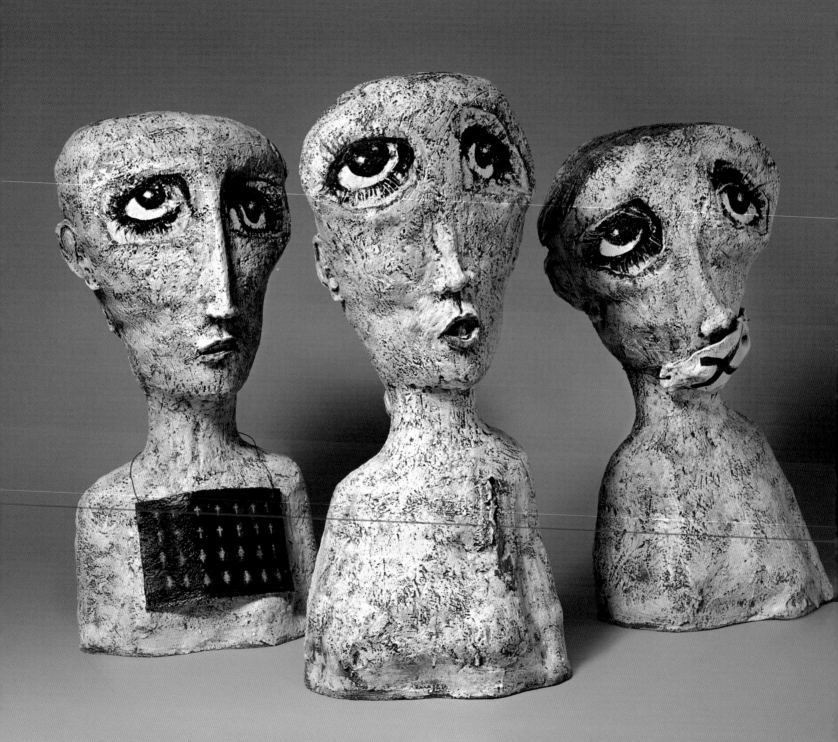

MY CERAMICS HAVE focused on human beings for a long time. I've progressed from manufacturing objects to explaining emotions without having completely left my past behind. I look for irony, complicity, the absurd, a scream, and also pain, sometimes the surprise of pain, behind a visible face, especially through its eyes. I want my work to ask the viewer "Why me?" This aggressive world troubles me; I know I can't do anything to stop it, but I try to portray it through a strong material such as ceramic.

I like people's faces; I'm attracted to their eyes. They seem so expressive that I try to paralyse them, to hold them, to eternalize them within the fragility of clay. I want them to be more than just a decorative anecdote. They should transmit human sensations. I am on a personal journey that is figuratively expressed and that does not bother me at all; it's like returning to my principles after less realistic periods. Photography helped me considerably in capturing expressions that I then use in my figures.

I sometimes find myself talking to the inconclusive heads that I've created. Sometimes I tell the women:

> The curve of your mouth has been carved with a knife, and your eyes remind me of so many others that I've glanced at, eyes that can be made to shine with iron oxide and feldspar. Don't fall; hold on, little being, which I sense in Burma, Africa, Barcelona, anywhere in the world I've traveled. Smile and look at our strange world. You're lucky to be made of clay; you contain part of our universe, but you don't suffer; you're paralysed and numb; you represent what I want to say—that you're sad, manipulated, and exploited, despite the fact that you're missing part of your body and your soul.
>
> But I always find you sad. Whether little girl or woman, you are victim and assailant at the same time. Troubled, ruthless, or tender, you move in my inner self, my impotencies and limitations. Often I don't want to form you. I want to freely press the soft clay, to pass it through my hands, to fight with it and simply appreciate its capacity for expression, rather than to shape something concrete. I want to allow myself to be carried away.

I tell them that my experience and your heat will give them life. I tell them that they're pretty and strong, that we both love them, and that they'll probably live longer than us, stopping a bit of time.

T. G.

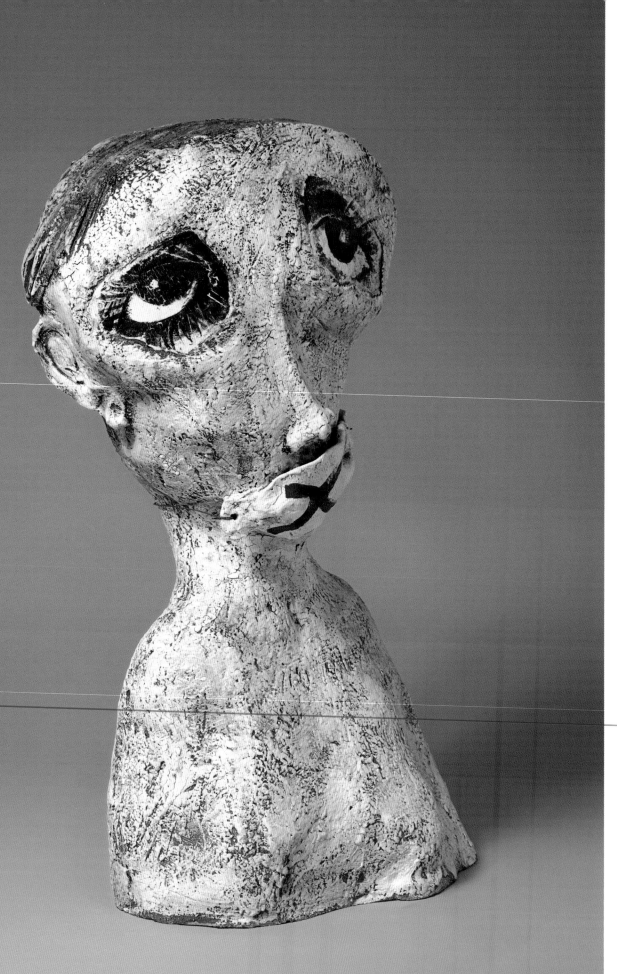

Teresa Gironès

Left:
Víctima (Victim), 2012
Courtesy of the artist

Opposite:
Víctima (Victim), 2012
Courtesy of the artist

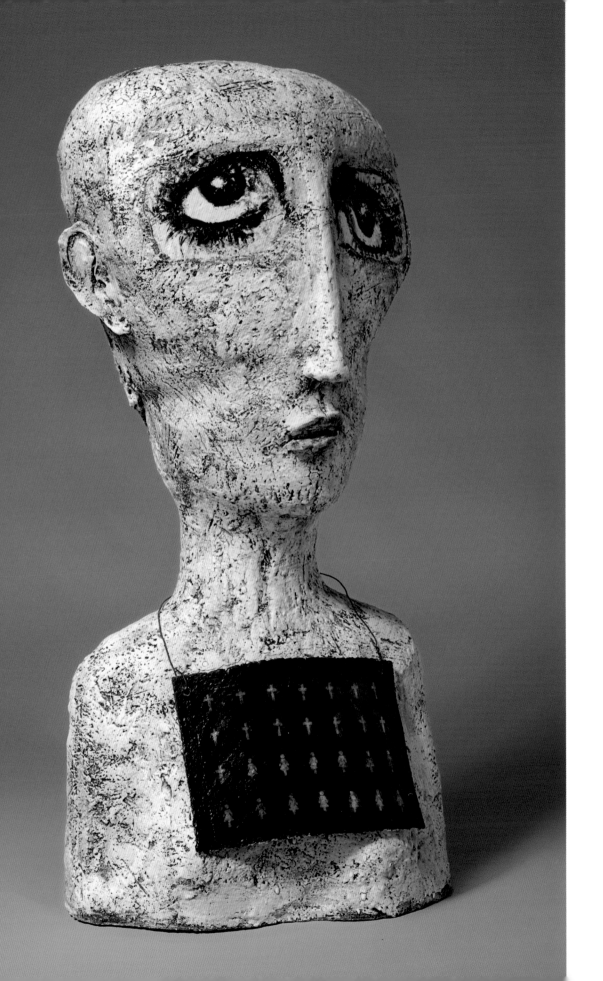

AFTER A LONG detour through the natural sciences and then abstract, doughy painting, I took another detour, where I modeled details of the body—intestines, anuses, hearts, phalluses, feet—as votive offerings, anatomical fragments, or heraldic representations. At last I resigned myself to sculpt complete figures from head to foot. This return to basics took the form of exoskeletons on the one hand and their inverse the other.

The texture of *David et l'Oeil de Goliath* (*David and the Eye of Goliath*) calls to mind as much the anatomical preparations of Honoré Fragonard as the aquatic living dead of *Pirates of the Caribbean*. These corals are the outer shell turned inside out. They could be the soggy parts shielded by armor or space suits.

The seated figures *Riri* and *Fifi* began by my making a cast of my wife's body, without knowing the purpose. I used a found piece of plastic to create a textural surface on the clay. I have come to realize that this pattern looks like the eyes of the trilobites I collected when I was a young science fiction fan.

I don't try to depict a particular emotion, and I am often surprised when those who look at my work see expressions of pathos or drama. . . . It doesn't bother me at all, but sentiment only rarely plays a role in the stories I tell myself about these pieces. I give the viewer the entire responsibility for his or her readings and interpretations. For example, I try to make lace out of mud, and in the end it looks like a flayed David. I find it interesting to model a body like a Golem—like a fossil of the future.

M. G.

Michel Gouéry (French, b. 1959)

David et l'Oeil de Goliath
(*David and the Eye of Goliath*), 2012
Enameled terracotta, steel
94 1/2 x 19 3/4 x 11 7/8 in.
(240 x 50 x 30 cm)
Courtesy of Galerie Anne de
Villepoix, Paris

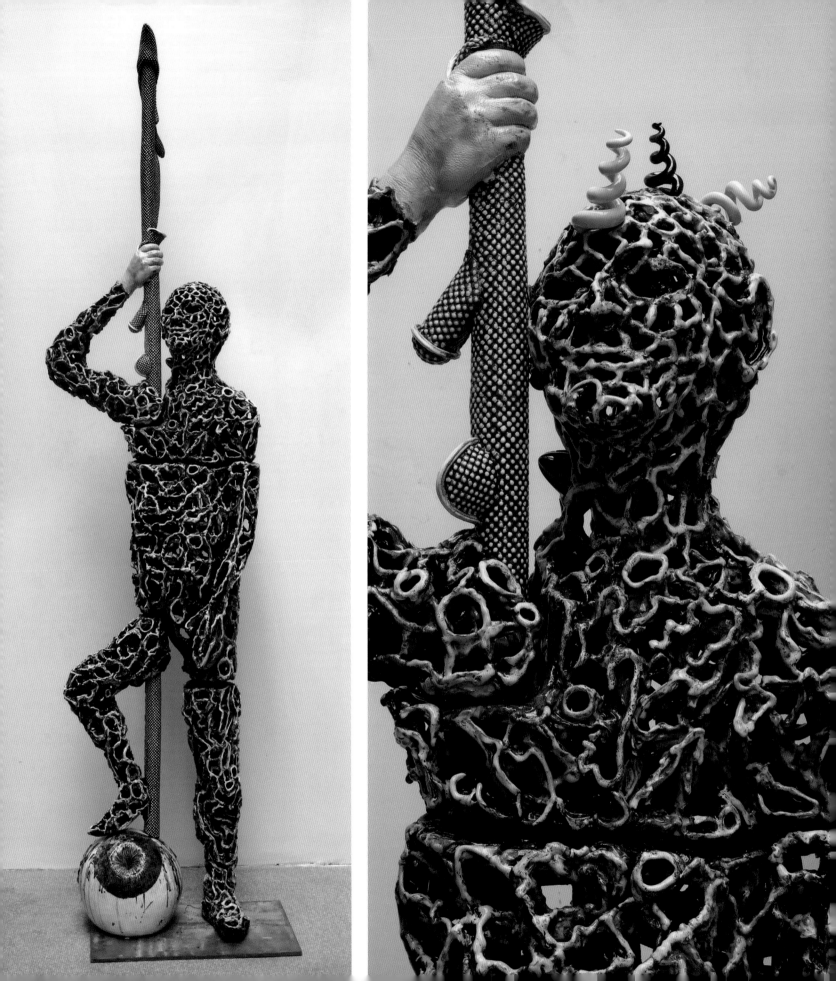

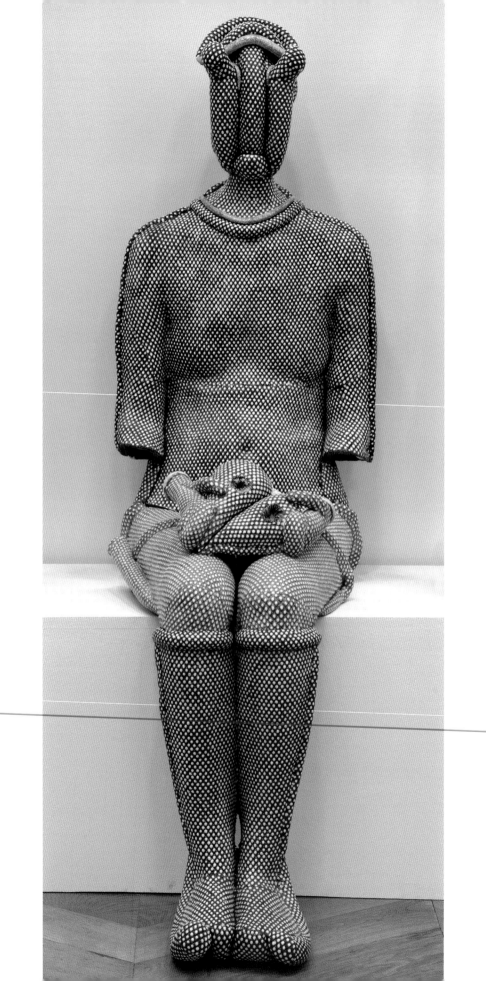

Michel Gouéry

Opposite:
Riri, 2006
Enameled terracotta
46 ½ x 15 ¾ x 21 ¼ in.
(118 x 40 x 54 cm)
Courtesy of Galerie Anne
de Villepoix, Paris

Michel Gouéry

Above:
Fifi, 2006
Enameled terracotta
47 ¼ x 14 ⅝ x 21 ⅝ in.
(120 x 37 x 55 cm)
Courtesy of Galerie Anne
de Villepoix, Paris

THE ACQUISITION of knowledge in the West, particularly our knowledge about the body, has traditionally been about breaking through a shell to an inner core to reveal hidden, inner truths. The Broken sculptures question this formula, as in their rupture an unexpected and impossible interior is exposed. This particular interior is overtly female, a space still found to be laced with taboo in a way that the male interior is not. The gender bias of an interior, invisible space is one of the themes addressed in this body of work, as the Broken sculptures flaunt their specifically female interior unapologetically, for all to see.

Our tactile associations with porcelain, a material of which we have a clear and physical tactile impression without the need to touch, generate a tension in the Broken sculptures. Here what should be hard is soft, what should be brittle is flexible, what should be fragile is fleshy, what should be precious is broken. These bodily expectations make ceramics an ideal medium with which to explore our tactile certainties of objects and the relationship between what is considered to be outside the body and what is believed to be inside.

My practice ultimately seeks to move away from a binary distinction between inside and outside the body, between the visible and the hidden, working with various materials to explore the relationship between these apparently defined bodily spaces. Using the surface of the body as a model for both looking and thinking, I move beyond a bi-directional inward/outward bodily framework to explore a mingling of skin and space, body and world.

As ready-made, mass-produced ceramics that I have found and reworked, the Broken sculptures exist alongside millions of their unbroken counterparts that reside on mantelpieces and in glass cabinets around the world. Counter to the idealistic and unrealistic way of living that the unbroken figurines illustrate, the Broken figurines describe a turning inside out of middle-class Englishness; a self-destructive ornamentation where object becomes organ, private becomes public, inside becomes outside.

J. H.

Jessica Harrison (British, b. 1982)

Andrea, 2013
Found porcelain, epoxy
resin putty, enamel
Approx. 8 x 5 x 5 in.
(20.3 x 12.7 x 12.7 cm)
Courtesy of the artist

Jessica Harrison

Emma, 2013
Found porcelain, epoxy resin
putty, enamel
Approx. 8 x 5 x 5 in.
(20.3 x 12.7 x 12.7 cm)
Courtesy of the artist

Jessica Harrison

Tippy, 2013
Found porcelain, epoxy resin
putty, enamel
Approx. 8 x 5 x 5 in.
(20.3 x 12.7 x 12.7 cm)
Courtesy of the artist

Jessica Harrison

Clockwise from top left:

Clare, 2013
Amanda, 2013

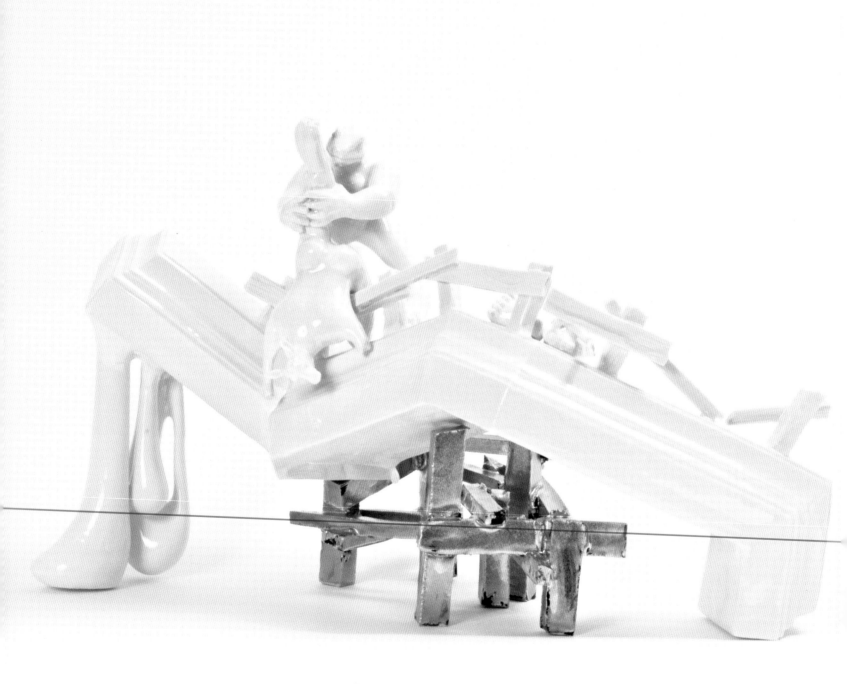

I AIM TO reinterpret the porcelain figurine and to examine the possibilities that I see the genre offering. I am dealing with both the narrative content and the creation and construction of the genre.

I seek to influence traditional thinking and blow up the box that the porcelain figurine has been locked in for a long time. My genre of conversational pieces has an unexplored potential to comment on the world. This belongs to a ceramic tradition that carries many virtues and features pretty little figurines in a vast and tradition-bound style. But these "harmless" figurines are expressions of an idealized world. This is the world I wish to portray in a new light.

My pieces become a twist on the classic porcelain figurines. The expected ceases to exist, and stories are turned upside down. The figures hint at something violent, unexpected, and wrong in the otherwise harmless frame of references.

My goal is to show a world full of anger, doubt, confusion, selfishness, lack of morality—and all their side effects. My work covers most of the range from simple meanness among children to political issues that affect countries. The focal point is to uncover the dark side of Man, since Man has more nuances than the typical porcelain figurine expresses, where the idyllic and utopian are typical.

All the pieces are made of porcelain, which can emphasize contrast between the pure and refined material and the untamed and uncivilized tableaux that I create.

The expectation that the porcelain figurine depicts an innocent situation is my crowbar to startle the viewer and surprise by showing a different situation.

L. H.

Louise Hindsgavl (Danish, b. 1973)

I'll Tear You Limb from Limb and Throw You Off a Cliff, You Adulterous Thief, 2011
Porcelain, stoneware, gold
12 ⅝ x 21 ⅝ x 11 ¾ in.
(32 x 55 x 30 cm)
Courtesy of the artist

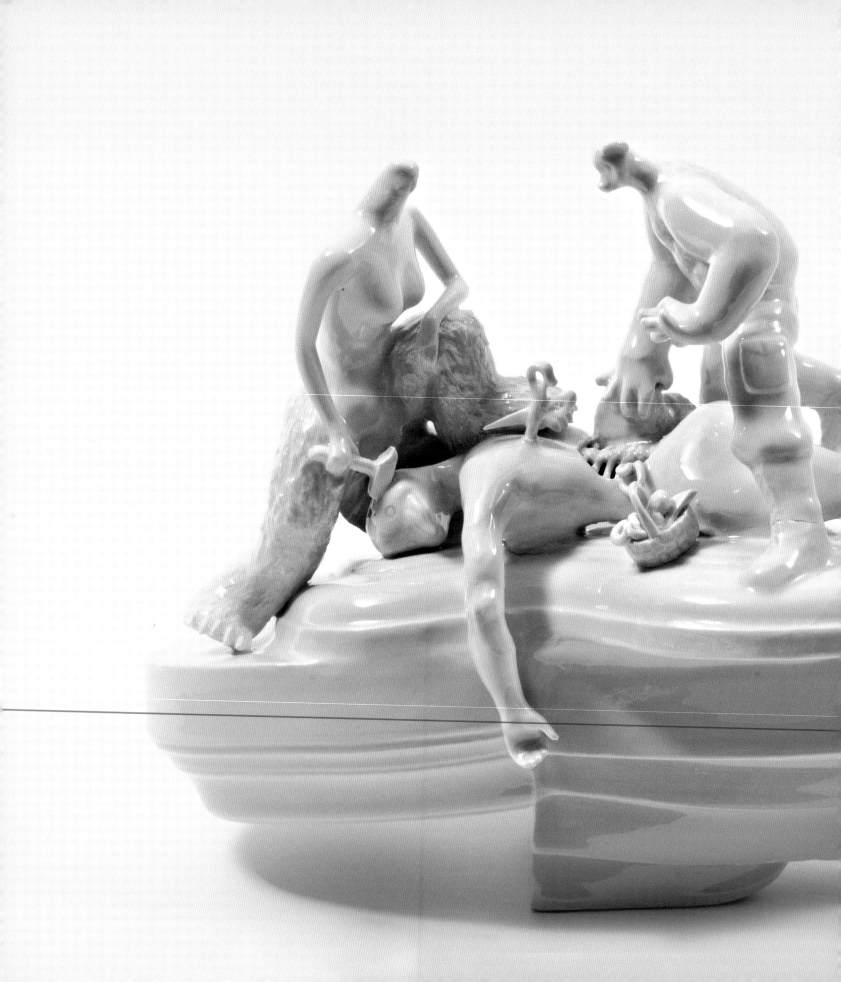

Louise Hindsgavl

The Volunteer, 2013
Porcelain
15 ³⁄₈ x 10 ¹⁄₄ x 10 ⁵⁄₈ in.
(39 x 26 x 27 cm)
Courtesy of the artist

ART IS A LIFESTYLE for me. Everything that surrounds and excites me is automatically processed and transformed into the final result: an artwork. It is fascinating to watch the transitions from life to art. The essence of my work is not the medium or the creative process, but human beings and their incredible diversity. When I think of myself and my works, I'm not sure I create them; perhaps they create me.

My work is about relationships. Everything that I live through and that surrounds me unconsciously goes into my artwork. Many of the people, both men and women, who are in my work look like me, but they are not specifically autobiographical. The stories that the characters reveal are equally non-specific. The emotions and relationships become universal or global in content.

I find ceramics to be the most versatile material; it is well suited to the expression of my ideas. I consider sculpture to be a canvas for my paintings. All plastic, graphic, and painting elements of the piece function as complementary parts of the work.

In my figures, torsos, and heads, the style is classical but the characters are comical. I like the contrast of serious to humorous; one side may be cartoonlike, but another view might feature an intimate painting of the being's spirit. While each piece expresses an individual personality or character, as a group they become a population, inhabitants of my imaginary world, or visitors from my imagination.

S. I.

Sergei Isupov (Russian/American b. 1963)

The Orchard, 2012
Porcelain
20 ½ x 14 x 7 ½ in.
(52.1 x 35.6 x 19.1 cm)
Courtesy of Barry Friedman Ltd.,
New York

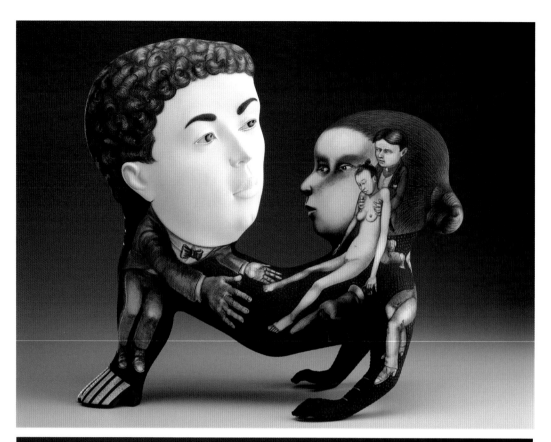

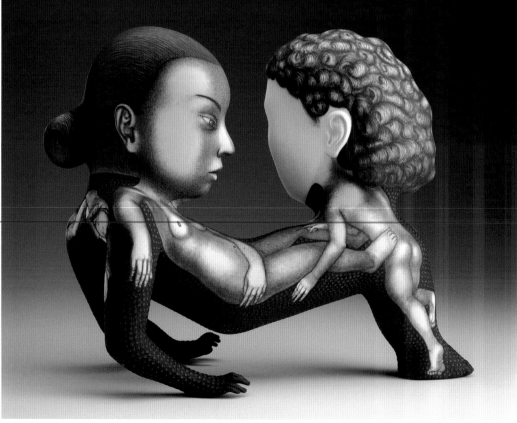

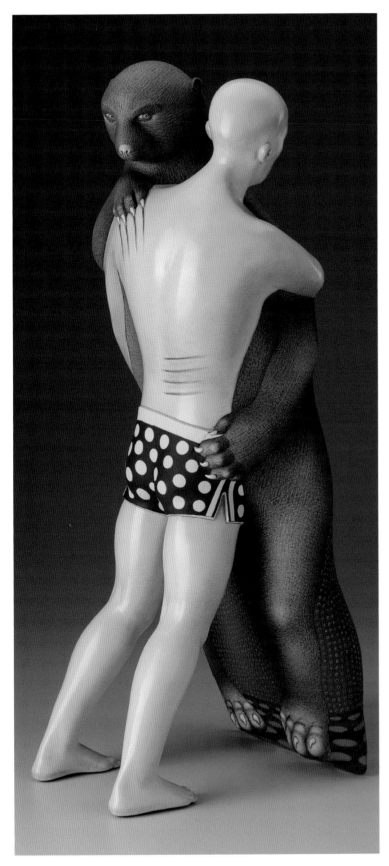
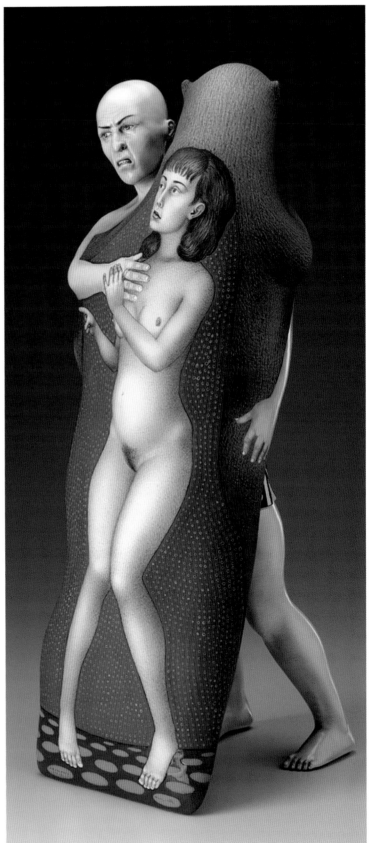

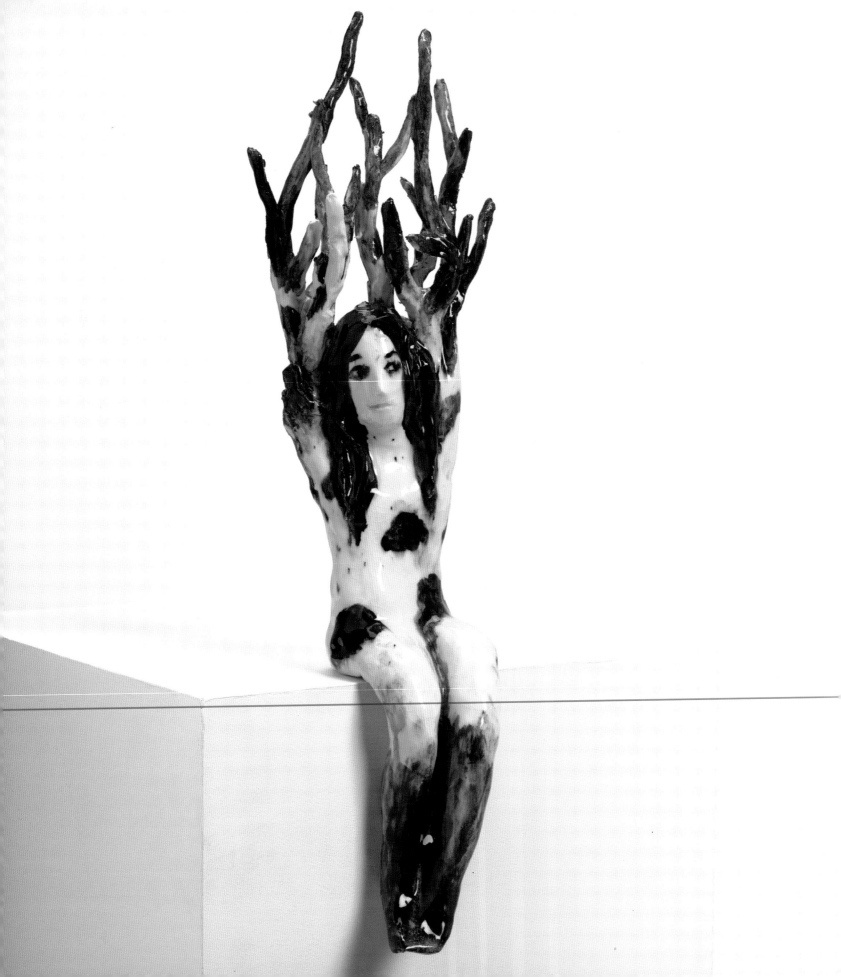

A SKILLED AND imaginative storyteller, Klara Kristalova draws inspiration from music, current events, and her daily surroundings to create figurative ceramic works that often mirror imagery from myths and old folk tales and that address themes relating to oppression, anxiety, and the subconscious. Exuding both innocence and horror, Kristalova's uncanny sculptures portray adolescent girls and boys who are often marked with exaggerated features or in the midst of transformation, bringing to mind memories of childhood fantasy, dreams, and nightmares.

Through the medium of ceramic, described by Kristalova as having once been "seen as a low material, and not serious enough, especially when glazed," the artist forms micro worlds with her sculptural figures. As art critic Anders Olofsson notes, her work "relates to a sculpture tradition that has its roots several hundred years in the past. In this tradition the three-dimensional artwork is seen as a means of three dimensionally 'educating' the viewer in a realm inhabited by both the viewer and the artwork simultaneously through their common physical relationship to the room."

Kristalova has recently presented pieces in various mediums, including ceramic, bronze, and works on paper, in a setting intended to reflect the artist's concept of an unsettling space. Kristalova crafts the environment to create a surreal atmosphere that places viewers in a flux between a dreamy, surreal place and an ordinary space where conversations and interactions occur.

Lehmann Maupin Gallery

Klara Kristalova (Swedish, b. 1967)

Growing, 2011
Glazed stoneware
24 3/8 x 6 7/8 x 6 3/4 in.
(62 x 17.5 x 17 cm)
Courtesy of Lehmann Maupin,
New York and Hong Kong

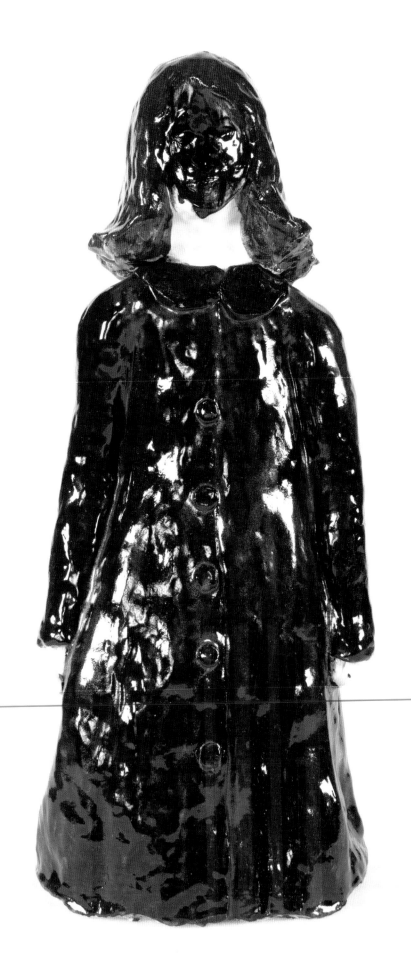

Klara Kristalova

On the Sunny Side, 2011
Glazed stoneware
30 x 17¼ x 17 in.
(76.2 x 43.8 x 43.2 cm)
Courtesy of Lehmann Maupin,
New York and Hong Kong

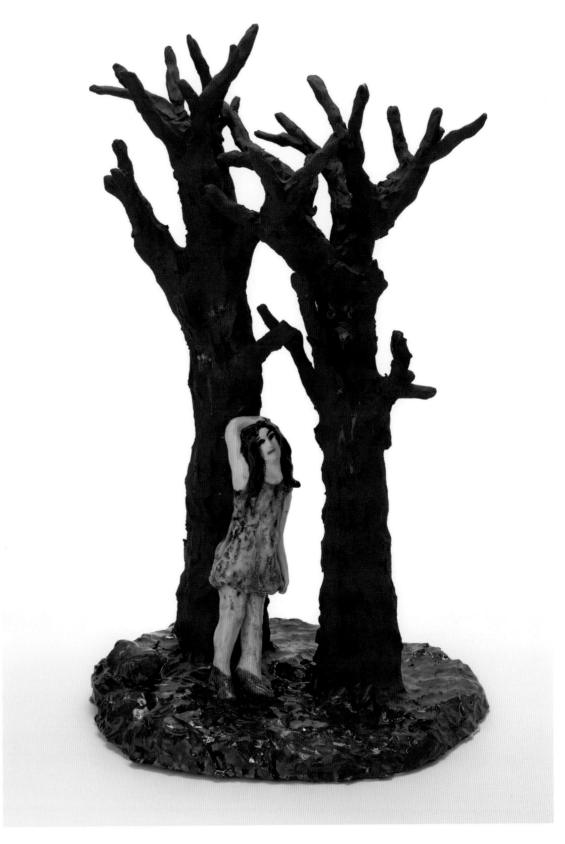

Klara Kristalova

Opposite:
Hollow, 2009
Glazed stoneware
39 ⅜ x 16 ⅞ x 13 in.
(100 x 43 x 33 cm)
The Speyer Family
Collection, New York

IT IS VERY tempting to compare Saverio Lucariello to Robert Arneson and go back to the Funk movement that Harold Paris described in 1967 in *Art in America* as "always biomorphic, nostalgic, anthropomorphic, sexual, glandular, visceral, erotic, ribald, scatological." The artist, in fact, ended up in ceramics through pure chance. And even though he has used almost all possible and imaginable materials in his art, he is primarily a painter. His work is not representational and embodies concepts far from narration or mimesis.

Lucariello has drawn heavily on conceptual art and has no desire to fall into the trap of illustration. His tripods topped with unlikely baskets of fruit and vegetables are decorated with heads molded from the artist's own face, but they are not to be seen as self-portraits. Instead, to paraphrase Deleuze and Guattari, these works can be seen as "desiring machines." Connected like rhizomes, these machines are driven by desire, an infinite and continual flow that sets the organisms in motion. Without vindicating it, Lucariello's paintings and ceramic sculptures seem to allude to this flow through these soft, swallowed, inhaled, defecated, or screwed forms.

The artist bases his work on the accumulation of sensations and the weight of our cultural baggage. He joins a trend in contemporary artistic creation that has recourse to pathos and its different expressions. Laughing is of notable interest and particularly preoccupies him. This "practical phenomena for decongestion," to allude to the French philosopher Georges Bataille, is the evacuation of what cannot be assimilated. It is the expression not of inner content but rather of unease, doubt, or refusal. Goethe mentioned the relationship between laughing and crying. But in fact Lucariello does not make clear if it is jovial or sardonic laughter.

Laurent de Verneuil

Saverio Lucariello (Italian/French b. 1958)

Untitled (detail opposite), 2008
Glazed earthenware
11 ¾ x 27 ½ x 16 ⅞ in.
(30 x 70 x 43 cm)
Courtesy of the artist

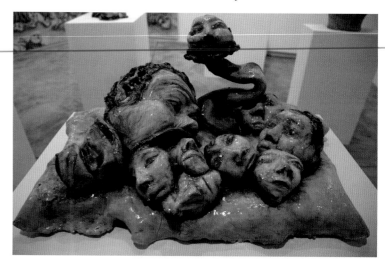

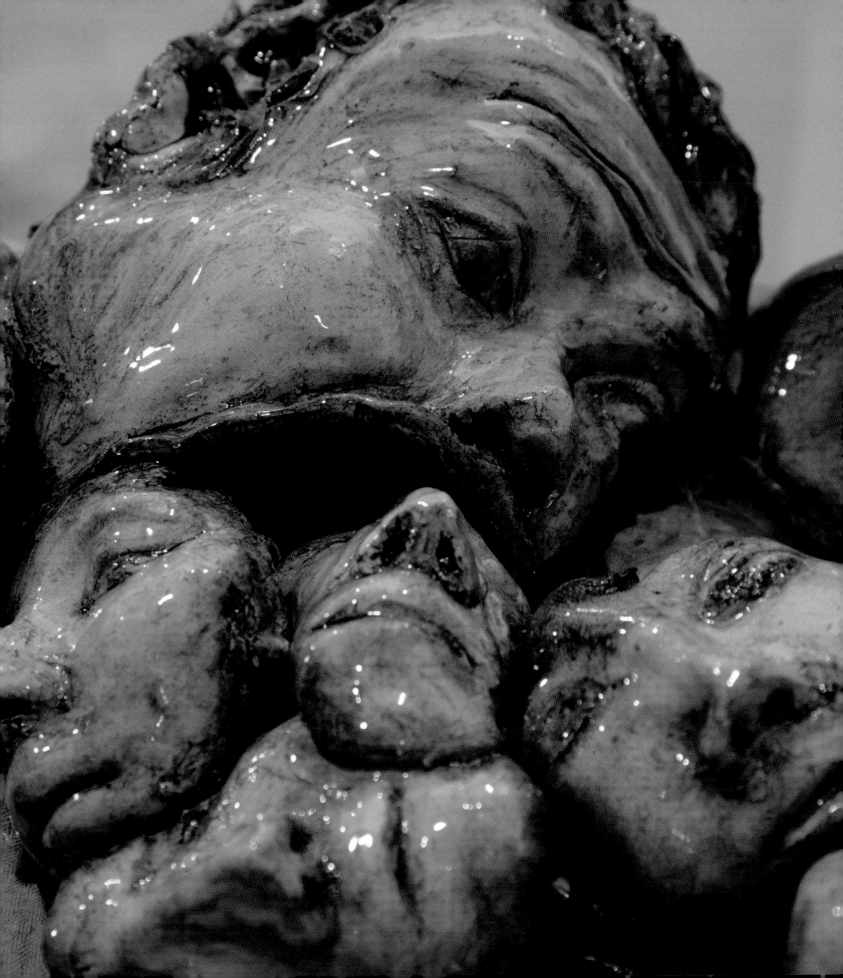

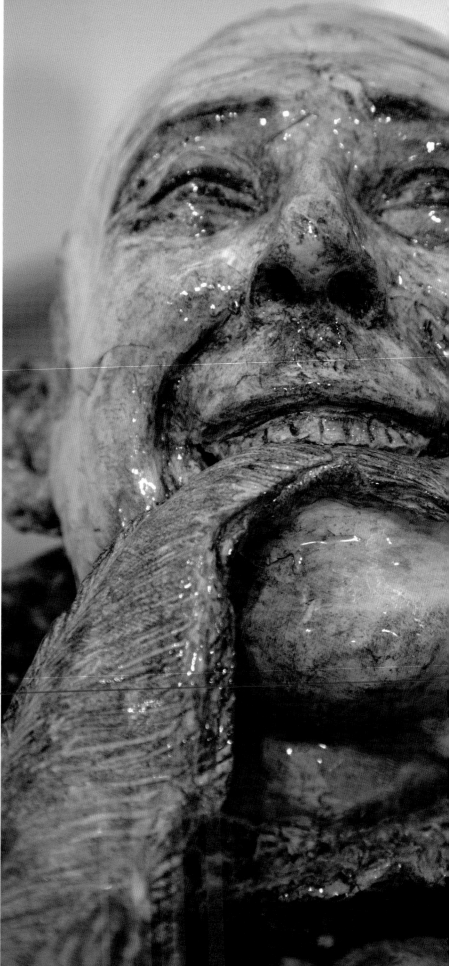

Saverio Lucariello

Vanitas au Poisson
(Vanitas with Fish), 2008
(detail right)
Glazed earthenware
11 3/4 x 17 5/8 x 11 1/2 in.
(30 x 45 x 29 cm)
Courtesy of the artist

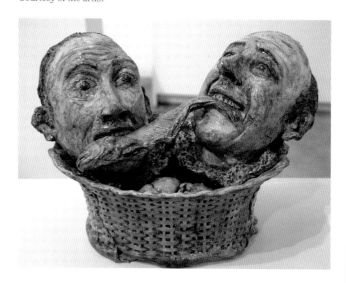

Saverio Lucariello

Opposite, right:
Tripode (Tripod). 2010
Glazed earthenware
48 x 32 x 32 in.
(121.9 x 81.3 x 81.3 cm)
Courtesy of the artist

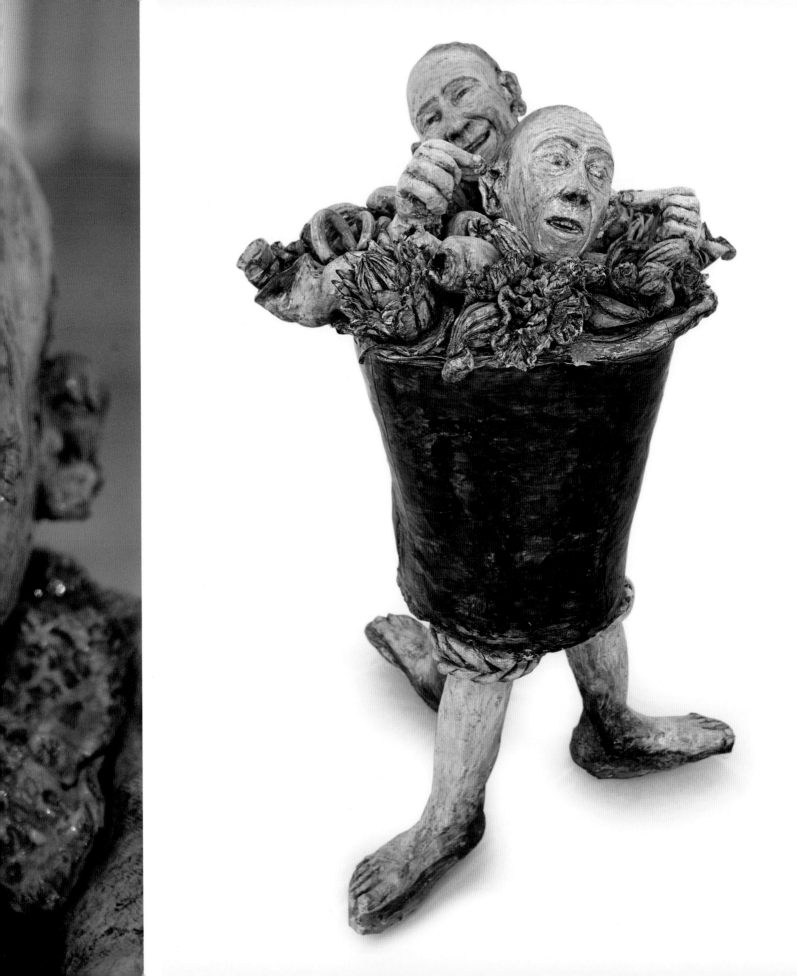

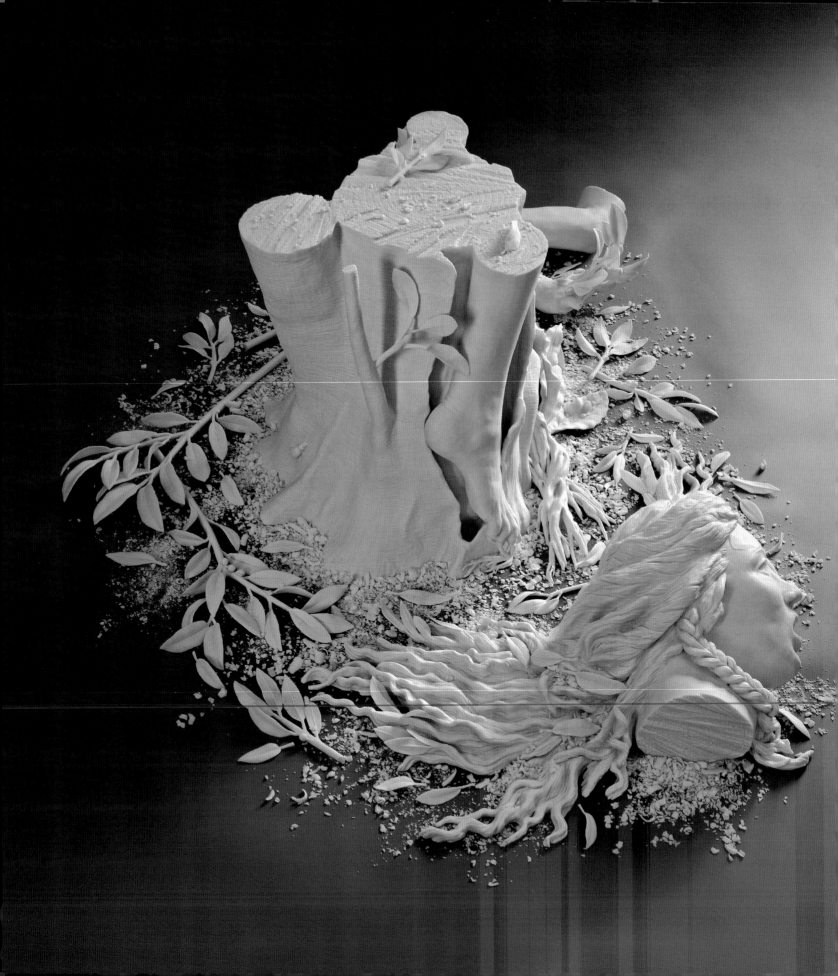

We do not want merely to see beauty, though, God knows, even that is bounty enough. We want something else which can hardly be put into words—to be united with the beauty we see, to pass into it, to receive it into ourselves, to bathe in it, to become part of it.
—C.S. Lewis

IN MY WORK, this romantic ideal of our relationship to the natural world conflicts with the reality of our contemporary impact on the environment. These pieces are in part responses to environmental threats—including air pollution, global warming, clear-cutting, and pesticide use—and environmental impacts—including rapidly declining plant and animal species. They also borrow from myth, art history, figures of speech, and other cultural touchstones. In each piece, aspects of the human figure stand in for our selves and act out sometimes harrowing, sometimes humorous transformations that illustrate our current relationship with aspects of the natural world.

I created *Daphne* in part as a response to my experiences as a backpacker and hiker in Oregon and Washington stumbling across clear-cut zones. In this piece, Bernini's sculpture of Daphne pursued by Apollo is transformed by one additional step from woman to tree to clear-cut slash pile. The nymph's distress now reflects a different kind of "rape." Whether as eco-feminist analogy, a literal and symbolic deconstruction of an iconic artwork, or an alluring play of organic line and form, death and regrowth, my work invites viewers to think about what is lost with environmental degradation, what sensory delights of texture and form are removed as we allow part of our body to be cut away.

K. M.

Kate MacDowell (American, b. 1972)

Daphne, 2007
Hand-built porcelain
17 x 53 x 40 in.
(43.2 x 134.6 x 101.6 cm)
Collection of Karen Zukowski
and David Diamond

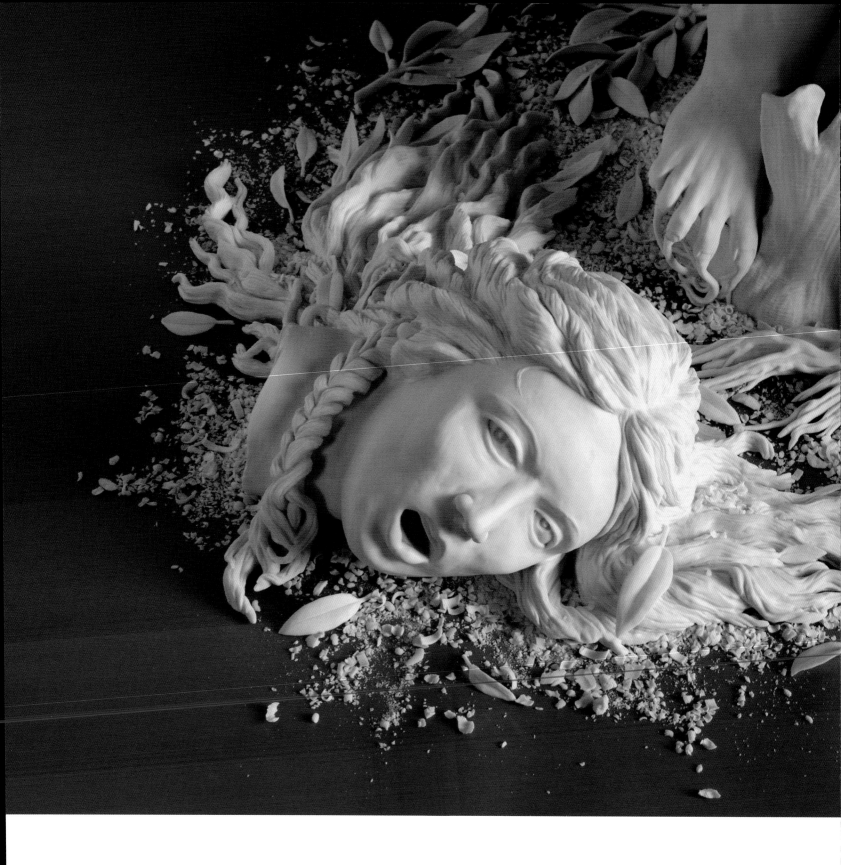

Kate Macdowell

Daphne (details), 2007
Collection of Karen Zukowski
and David Diamond

PLAY, THROUGH its rules, limits the use of violence. Yet there have been eras when a fatal outcome was not necessarily ruled out. Conversely, war, in its archaic forms, could take on the trappings of a game. This same duplicity between playing and fighting is at the heart of Myriam Mechita's oeuvre; she explores even their darkest versions, an always serious reminder of our finiteness.

Through a kind of mimicry, some of her works appear as pure surfaces, even though they offer the illusion of three-dimensionality. They are more like evocations, skeletons of images or objects reduced to their most elementary form: a sort of generic volume drawing.

The use of materials that shimmer and produce other reflections helps to create a decoy, a mirage, a dreamt form: a glow that one is unsure about having seen, so strongly does it dissolve what it is supposed to constitute and makes it unreal and relief-less.

Legend has it that silk's arrival in the West had fairly similar effects: the Roman legions were supposedly frightened by the colored silk banners borne in the wind by their Parthian enemies. The evocative power of these unfamiliar flags, the scintillating silk with its incredible lightness and the way it swelled in the wind, made a scarecrow— an oriflamme so convincing, it is said, that the Roman army was routed. The illusion produced here is of the same order, except that we are playing with a dead thing. We simply want to believe in what we know is fake.

Sandra Cattini
(translated by Paul Jones)

Myriam Mechita (French, b. 1964)

Le Silence des Vagues
(*The Silence of the Waves*), 2011
Porcelain, nylon
31 1/2 x 15 3/4 x 15 3/4 in.
(80 x 40 x 40 cm)
Courtesy of the artist

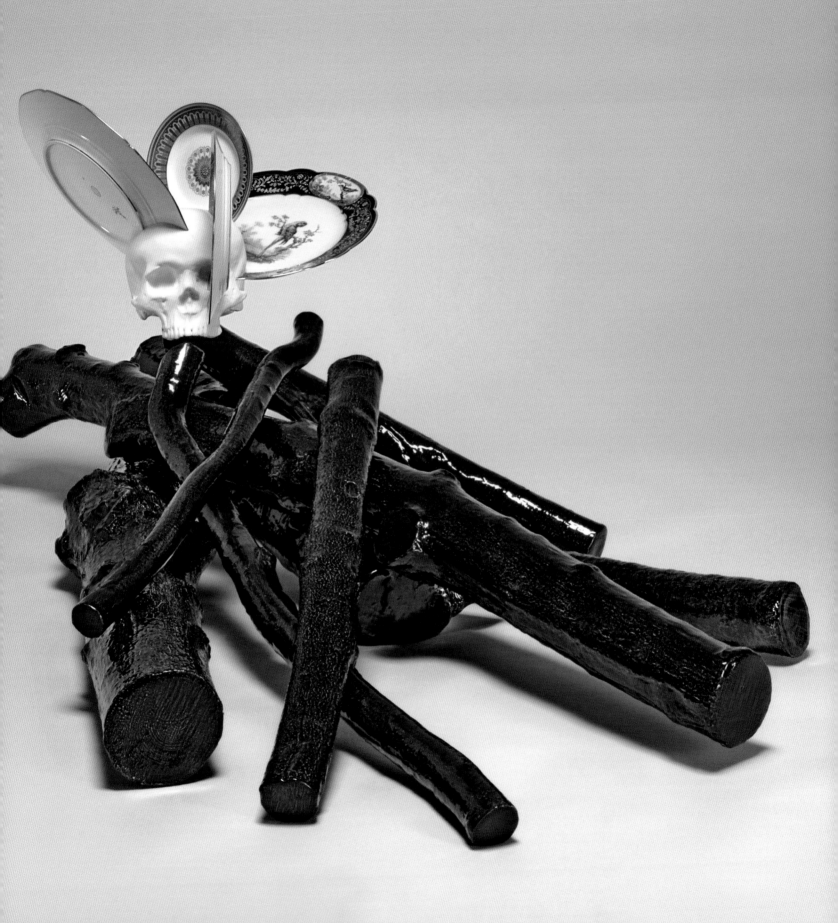

MARLÈNE MOCQUET considers herself primarily a painter and denies any dialectic opposing abstract and figurative work. She denounces, as a false issue, all questions raised about the legitimacy of the technique used by an artist. Even though ceramic is not her primary artistic medium, it has nonetheless enriched her work and introduced perspective and volume. However, she is interested less in the three-dimensional aspect than in the metamorphosis that ceramic allows.

Metamorphosis dwells at the heart of Marlène Mocquet's pandemonium and chimerical visions. It recalls Giordano Bruno's hylozoistic notion in which all matter is alive. In her painting, the artist considers all figures, objects, or landscapes to be living beings in the continuous flow of a mental landscape. She even feels consumed by the painting, and such a relationship to the medium brings to mind the myth of Actaeon. Metamophosed into a stag and torn into pieces by his own dogs, the famous hunter symbolizes the man preoccupied by his thoughts who ends up being consumed by them. This metaphor of the search for truth immerses our selves in the cathartic art practice experienced by the artist.

Mocquet seems to stage childhood fantasies and dreams inhabited by chimeras and monsters. Such creatures awaken primitive fears in man. The artist may project her imagination in her works, but in return she expects these to nourish her. To quote Gilbert Lascault, "the monster thrives on fantasies; in return he nourishes fantasies." The monster calls upon our pathos more than our will-to-know.

Laurent de Verneuil

Marlène Mocquet (French, b. 1979)

Opposite:
La Nature Sort de la Bouche
(*Nature Leaves from the Mouth*), 2012
Enameled stoneware
4 ¾ x 14 ¾ x 10 ¼ in.
(12.1 x 37.5 x 26 cm)
Courtesy of the artist

Marlène Mocquet

L'Alcidé Décidé (*The Alcid Decided*), 2012
Enameled stoneware
8 ⅝ x 7 ⅞ x 5 ⅞ in.
(21.9 x 20 x 14.9 cm)
Courtesy of the artist

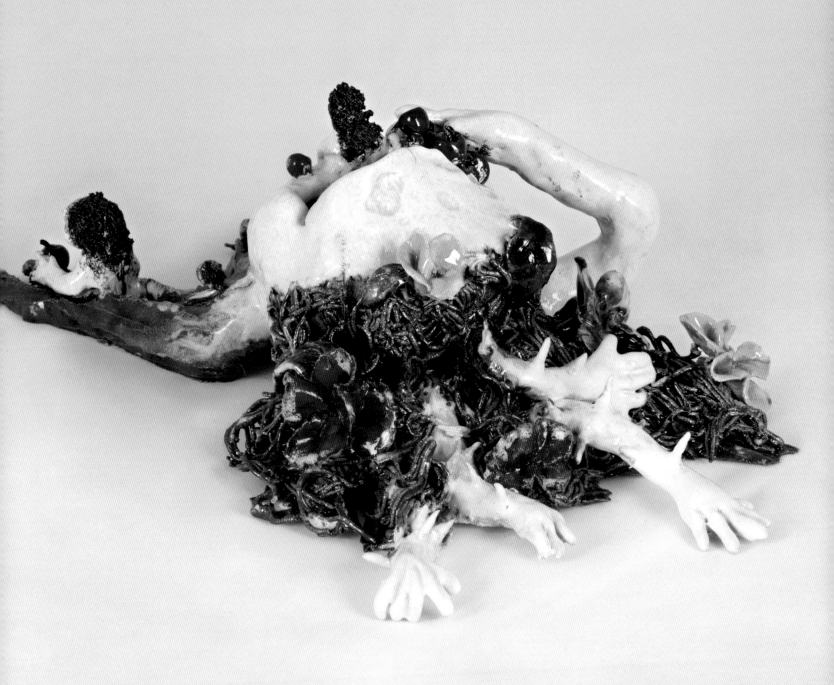

Marlène Mocquet

Hommage à Sam Francis, Bosch, Munch, et à L'Inde (Tribute to Sam Francis, Bosch, Munch, and India), 2011
Mixed media on canvas
38 ¼ x 51 ⅛ in.
(97.2 x 129.9 cm)
Courtesy of the artist

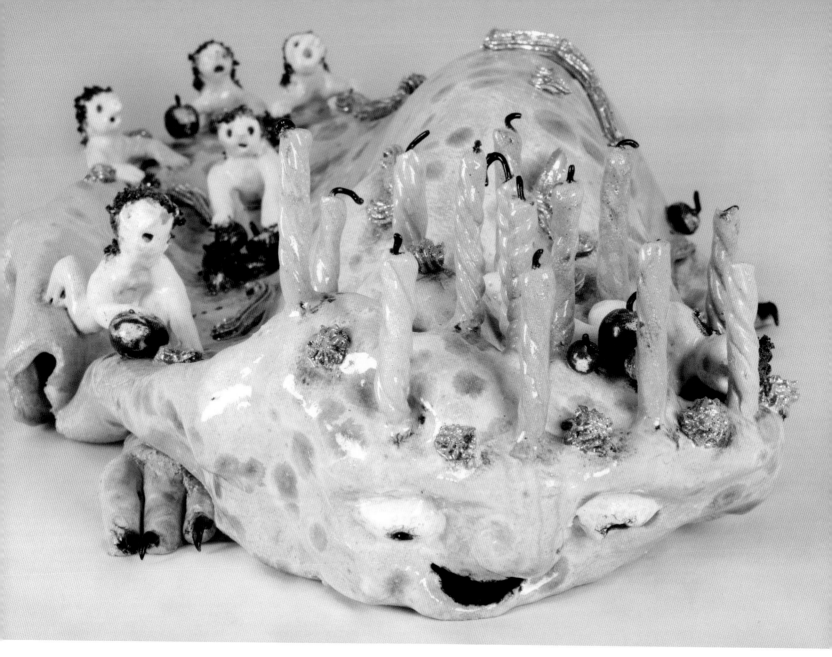

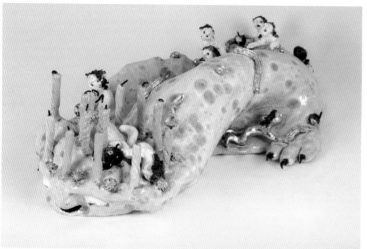

Marlène Mocquet

La Beauté Animale de la Vie
(*The Animal Beauty of Life*), 2012
Enameled stoneware
5 1/2 x 12 5/8 x 23 5/8 in.
(14 x 32.1 x 60 cm)
Courtesy of the artist

BODY & SOUL is an exhibition that resonates and brings attention to issues that are both dear and important to me as a woman artist. As a solo world traveler, I seek out the comfort and protection of women in traditional cultures wherever I travel. I go to markets, which are dominated by women and where I know I will make new acquaintances. These women invite me into their lives. They guide me, teach me, feed me. Without a doubt they will have daughters. Their daughters soon become my guides, my language teachers, my new best friends. They teach me how to shop and barter for what I want; how to talk back and be fearless in their culture.

These were sassy little women/girls and I cherished my time with them and I adored them. In our exchange, our roles switched back and forth. At times traveling with them, they actually became my mother figures. Other times I was the mother. All of the time we were extended family. I could not help comparing the lives of the little girls I encountered on my journeys with the lives of little girls in our culture. There is a great difference, and sometimes the difference is heart breaking. At times, I could not wrap my heart and brain around some of the things I saw.

Thirty-five years ago, while I was living with the Mende people of Sierra Leone, West Africa, young girls would come to my hut every day. Our ritual of sisterhood began. They tried on my clothes, used my makeup, combed my hair. They taught me the Mende language and showed me how to wash my clothes on the stones in the river and how to cook my food placed on three stones. They taught me how to walk like Mende women, sit like Mende women, and eat like Mende women, never letting food touch my lips. More importantly, they kept me safe.

Suddenly one day they were gone. I looked for them; I asked the elders for them; I missed them. No one would tell me where they went. Three months later, they returned to the village CHANGED. They were no longer little girls. They no longer had the playfulness of the girls I had known, or the look of wonderment in their eyes. They walked differently, acted differently, and, shockingly, they didn't want to have anything to do with me. I could not understand, I didn't know why. I now know they were circumcised.

I left the Mende land never knowing what happened to these young girls. Nineteen years later I learned and tried to understand. I say keep the Ritual; it is important; but STOP the CUTTING.

S. M.

Sana Musasama (American, b. 1957)

SameSame, 2011
Stoneware
8 x 2¼ x 3½ in.
(20.3 x 5.7 x 8.9 cm)
Courtesy of the artist

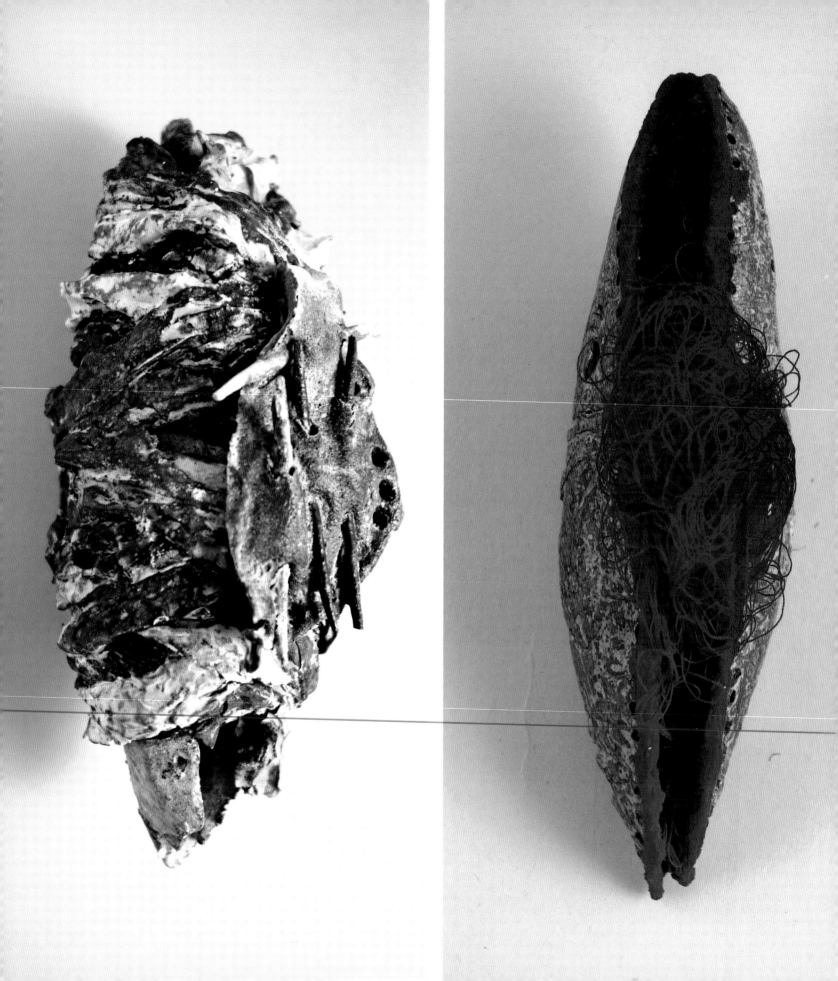

Sana Musasama

Opposite left:
Pins and Needles, 2011
Stoneware
6 x 2 ¼ x 2 in.
(15.2 x 5.7 x 5.1 cm)
Courtesy of the artist

Opposite right:
Cut, 2013
Stoneware, mixed media
7 x 2 ¼ x 2 ½ in.
(17.8 x 5.7 x 6.4 cm)
Courtesy of the artist

Sana Musasama

Stapled Shut, 2012
Stoneware
7 x 3 ¼ x 3 in.
(17.8 x 8.3 x 7.6 cm)
Courtesy of the artist

FIGURE DE L'AMONT (POUR M) #2 (*Upstream and Down [for M] #2*) is a sculpture dedicated to the memory of my father, Marceau Rochette, who died abruptly in September 2009. The violence of his death and the temporary wreck it made of my life finds neither release nor illustration in the work. Rather, the form and iconography of the sculpture came to be tied up intimately with the mourning and the welling-up of memories of my father. (The word *amont* is hard to translate; literally it means upstream, or uphill; in French it can be used in a more general way to imply a precursor, or to point to the origin of an event, a phenomenon, an action.)

The image of the figure swallowing or expelling a school of fish came from a dream that preceded his death: I was looking at my own breast, on which a large fish was firmly attached, sucking or biting it. The sensation was that of a continuous flow of liquid life between my body and the fish, an ambiguous sense of being both emptied out and fed by the fish. While I was in the process of working out that image, my father died, I lost my moorings, fell adrift, and looked for anything that stood up to my sense of loss. The figure had become male, the breast a mouth, and the fish multiplied.

Slowly associations came, the old Fisher King, the wounded keeper of the grail, ruler of the wasteland, the final enemy and ally of the quest, as well as half-remembered stories of my father, trout fishing with his father and then with his own son. In working the clay, I made decisions concerning scale and placement in a very intuitive way; the figure was relatively small so as not to overwhelm, and the supporting column was conceived to provide the height necessary for a sense of remoteness.

Circuitously I had stumbled upon the eremitic, reclusive pillar, a long-established locus of the quest for sense.

A. R.

Anne Rochette (French, b. 1957)

Figure de l'Amont (pour M) #2
(*Upstream and Down [for M] #2*)
(detail), 2010
Courtesy of the artist

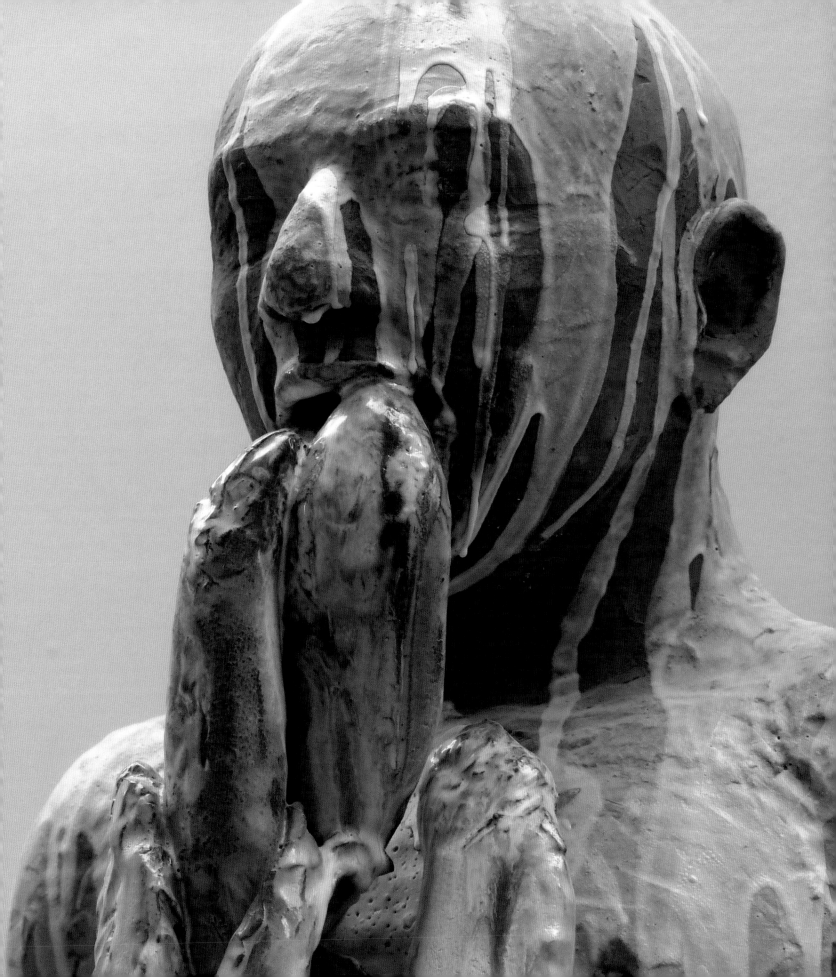

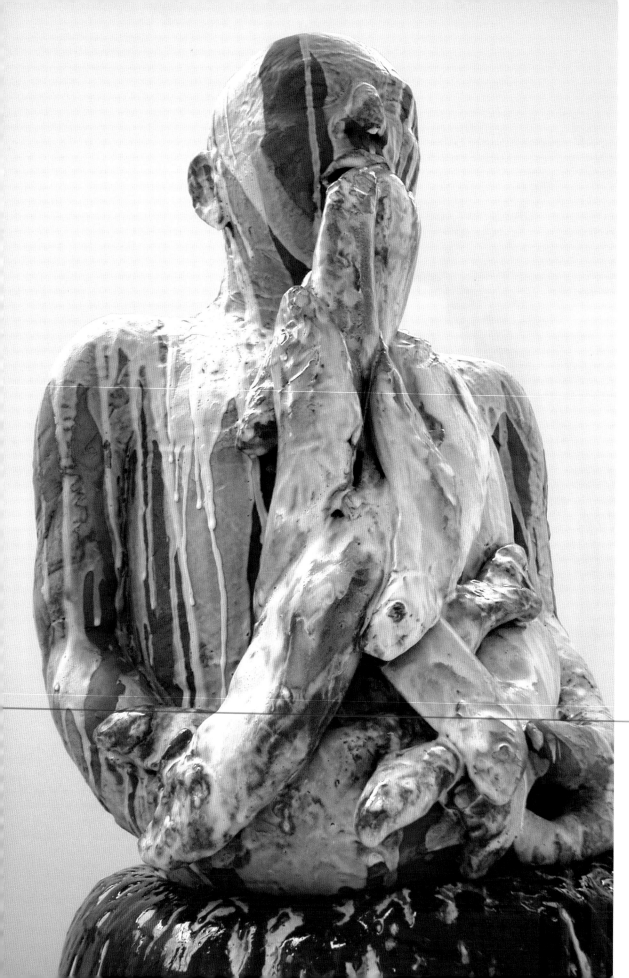

Anne Rochette

Figure de l'Amont (pour M) #2
(Upstream and Down [for M] #2)
(detail), 2010
Courtesy of the artist

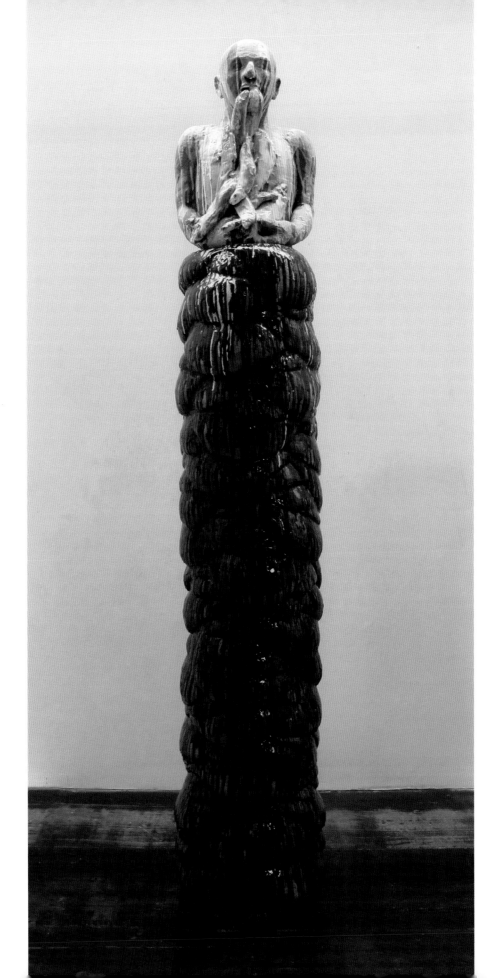

Anne Rochette

Figure de l'Amont (pour M) #2
(*Upstream and Down [for M] #2*), 2010
Glazed earthenware
90 ½ x 18 x 17 in.
(229.9 x 45.7 x 43.2 cm)
Courtesy of the artist

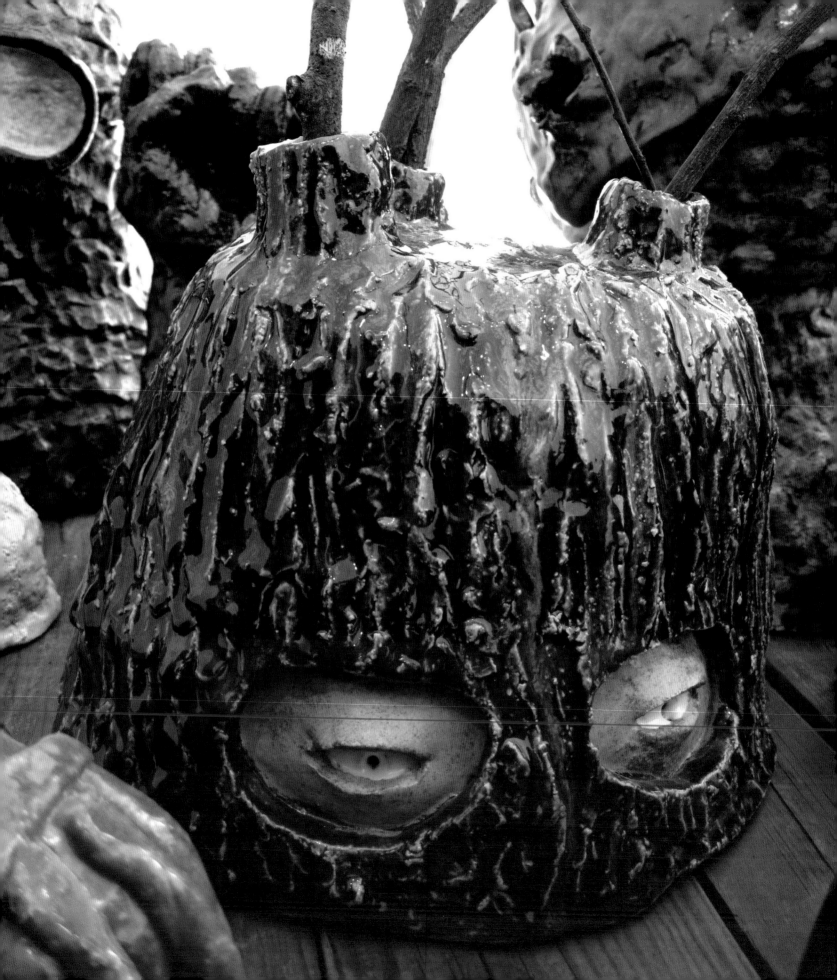

The youth are waiting, day after day. They wait for their time; as do the workers, even the old. They all wait, those who are discontented and who reflect. They are waiting for a force to arise, something they will be part of, a kind of new international that will not make the same mistakes as the previous ones. They wait for a chance to get rid of the past once and for all—for something new to begin. We have begun.
—Anonymous French manifesto, 2003

L'ASSAUT (*The Assault*) is a mix of contemporary and old imagery about war and rebellion. The faces come from different times of history or are inspired by contemporary facts or movements. These characters are summoned on a single battering ram or tank for a last assault, for a great pre-apocalyptic battle. An association of rebels coming all the way from every corner of the world and time, to raid the city and challenge its masters. This evergreen image has and will always echo in present and future times.

C. R.

Coline Rosoux (French, b. 1984)

L'Assaut (*The Assault*) (detail), 2010
Earthenware, wood
Courtesy of the artist

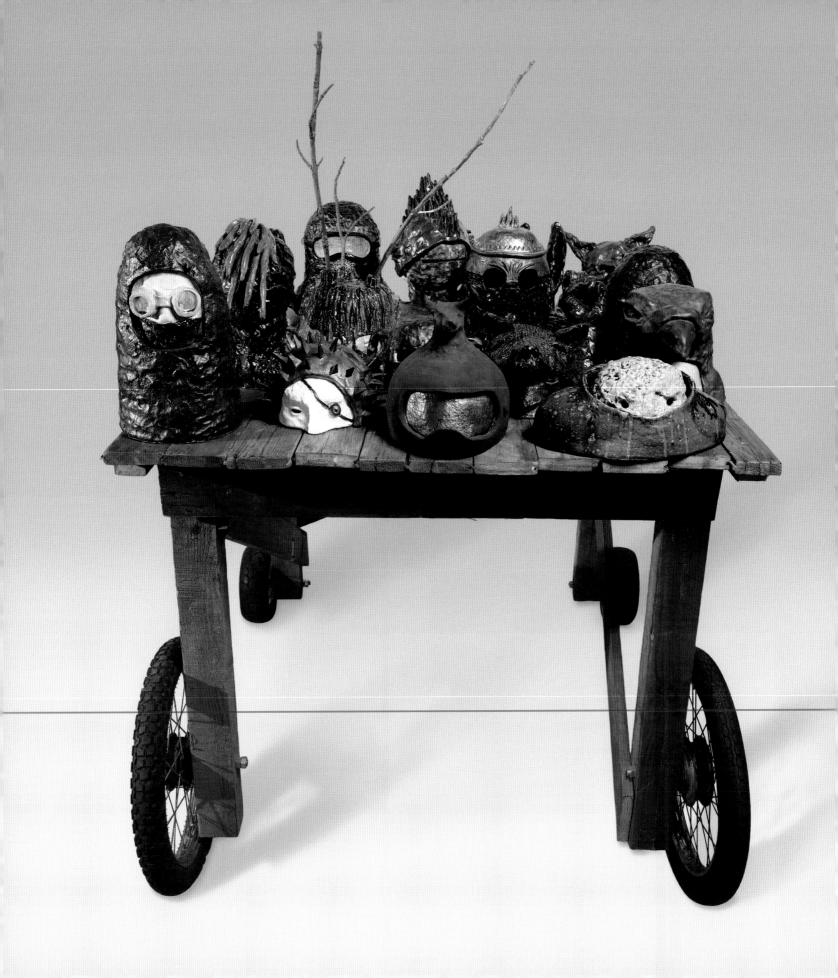

Coline Rosoux

L'Assaut (*The Assault*), 2010
Earthenware, wood
63 x 47¼ x 47¼ in.
(160 x 120 x 120 cm)
Courtesy of the artist

Coline Rosoux

L'Assaut (*The Assault*) (details), 2010
Courtesy of the artist

ELSA SAHAL's creations in clay are struggles of manual intellect against collapse. She manipulates vast sheets of clay whose thickness is conditioned by the needs of the pieces she is creating. Without respect for physical laws, the clay folds and collapses. Without the balance of the forces—the ligaments, the muscles, and the thought of the artist on one side and the weight, the density, the texture of the stoneware on the other— nothing would come from the action of creation.

The *Pieds Noirs* (*Black Feet*) is made of two robust and symmetrical feet on which two perfectly wheel-thrown skittles are stacked. The feet remind us of antique marble statues supporting giants that are present all around the Mediterranean Sea.

In the classical statuary when the hands make a sign and draw all the attention, the feet establish themselves as pedestals. Therefore, the sculpture does not seem erected from the ground but standing firmly on it. The authority of the feet is lightened by the round skittles, which take the place of legs. They let us imagine a body which is arranged like overlapping roof tiles, creating something similar to a wood puppet with laborious articulation, reducing monumental sculpture to a doll game.

The *Pieds Noirs* sculpture is a hybrid figure, formed through another process, which has more to do with collage. It is the illegitimate fruit of an absurd union of two different visual languages, two different moments in history, both questioning identity and heritage. The quest for identity takes place in the story of the French colonials during the twentieth century, such as the Sephardic Jews who lived in the French territories of North Africa (Algeria, Tunisia, Morocco) and were naturalized by France during the first part of the century. With the Wars for Independence, they had to leave those countries, but when they arrived in France, they were derided as "pieds noirs" (black feet), as if they had walked back to France and arrived with real "black feet."

E. S.

"My family never really talked about this past, but I know that their arrival in France was very difficult. My father always claimed he was French, because of what he was building: a life, a family, to find his place in the French country and culture."
(based on curators' interviews with the artist, 2012)

Elsa Sahal (French, b. 1975)

Pieds Noirs (Black Feet), 2010
Stoneware
47¼ x 27½ x 27½ in.
(120 x 70 x 70 cm)
Courtesy of Claudine Papillon
Galerie, France

Elsa Sahal

Autel n°2 (Altar n°2), 2012
Stoneware
29 ½ x 13 ¾ x 23 ¾ in.
(75 x 35 x 60 cm)
Courtesy of Claudine Papillon
Galerie, France

(not included in the exhibition)

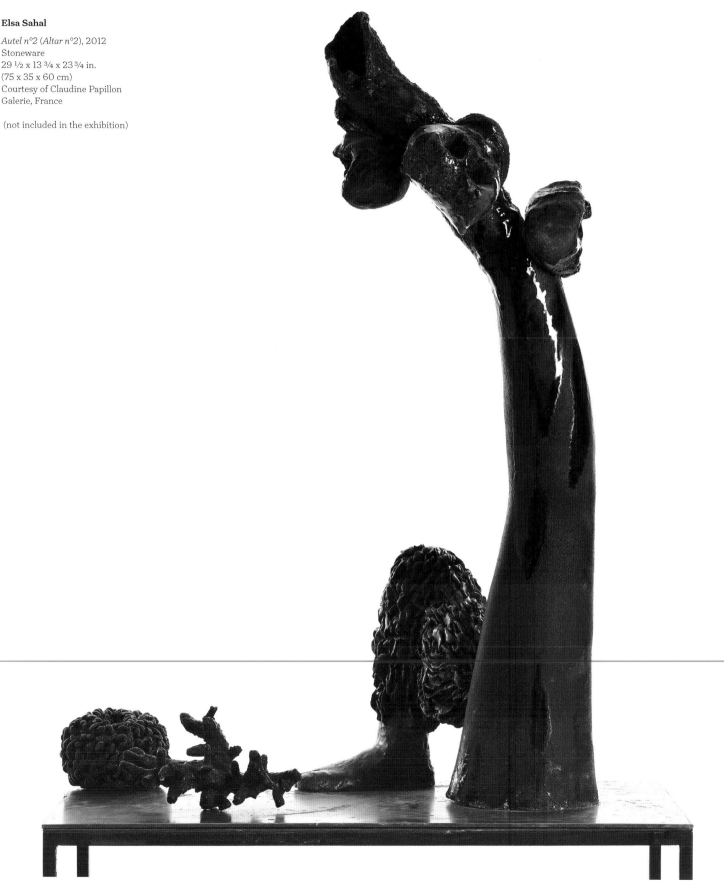

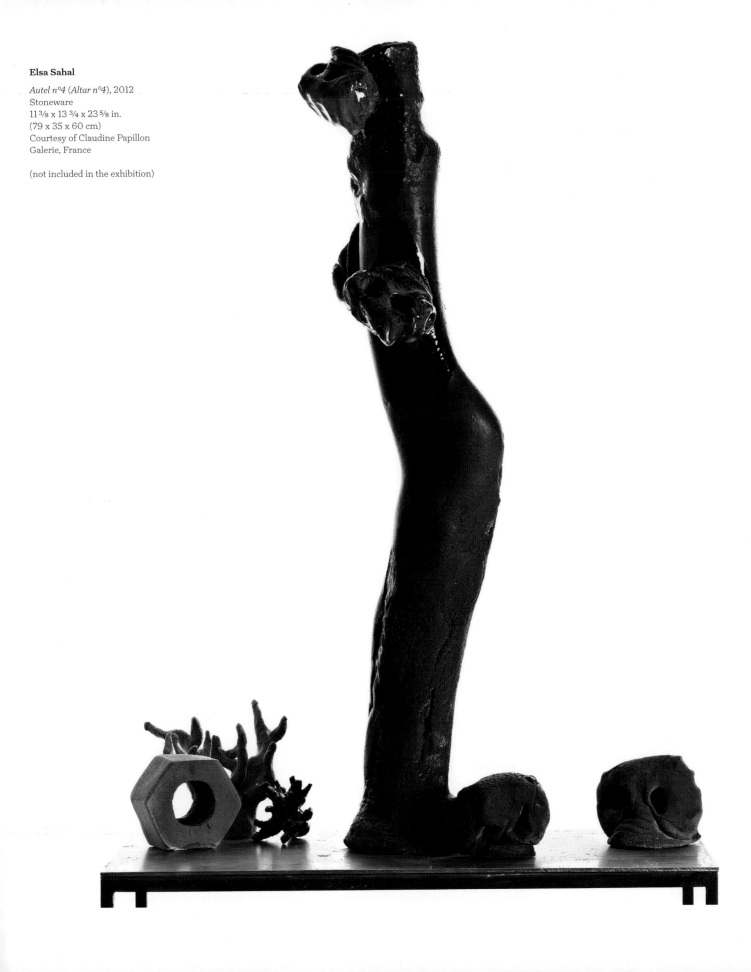

Elsa Sahal

Autel n°4 (Altar n°4), 2012
Stoneware
11 ³/₈ x 13 ³/₄ x 23 ⁵/₈ in.
(79 x 35 x 60 cm)
Courtesy of Claudine Papillon
Galerie, France

(not included in the exhibition)

CREATING ART WITH hands is both primitive and human. It is what differentiates us from other species. I find it necessary to use this possibility, which is given to us, to use my physics and my motor skills when I sculpt. I need to feel the material; I need to find the details that make every piece unique. With clay you can't disturb the material too much. It seeks the time to develop itself.

I combine this ancient material with contemporary imagery. Although I'm fascinated by the historical tales, most of my sculptures are a mixture of old technique and the popular culture that surrounds us today.

I play the game of innocence. Children and animals are my actors. They present disturbing acts that aren't expected from them. Sometimes the aesthetic surface almost hides the horror.

At the same time, I want to open the minds of the viewer and bring the gaze back to them. Does the world need another innocent child, or are we damaged from the beginning? Or is it the world of the adults played by the children that unveils the hidden?

K. S.

Kim Simonsson (Finnish, b. 1974)

Untitled, 2013
Glazed stoneware
49 ¼ x 78 ¾ x 39 ⅜ in.
(125 x 200 x 100 cm)
Courtesy of the artist

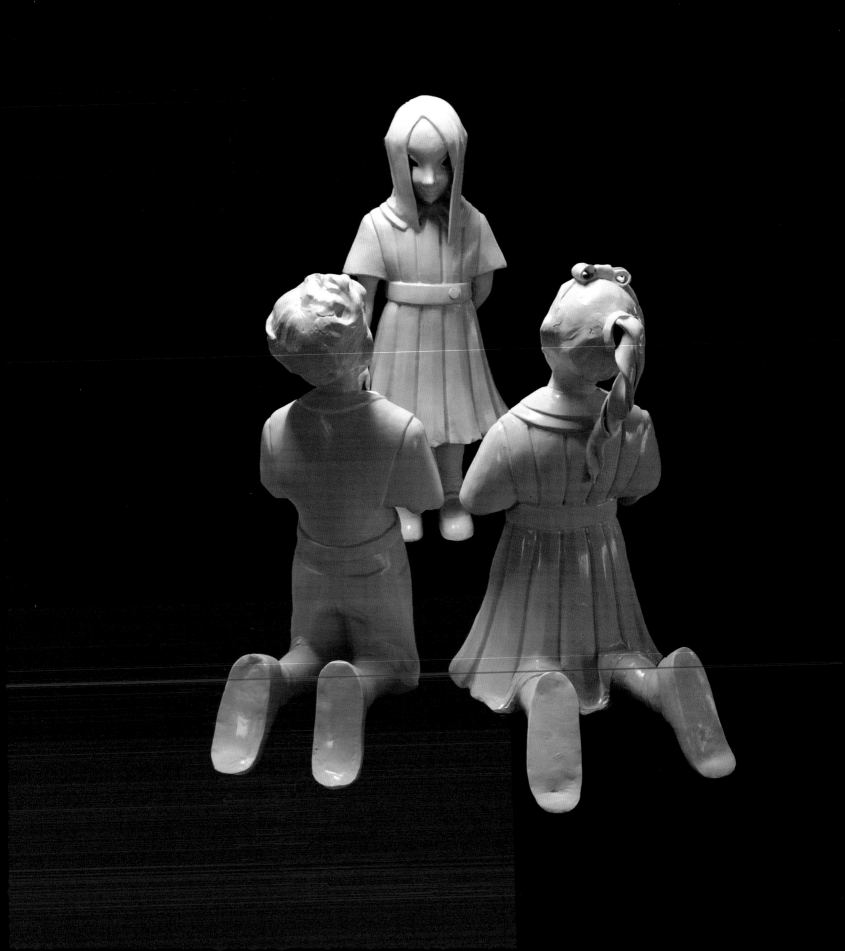

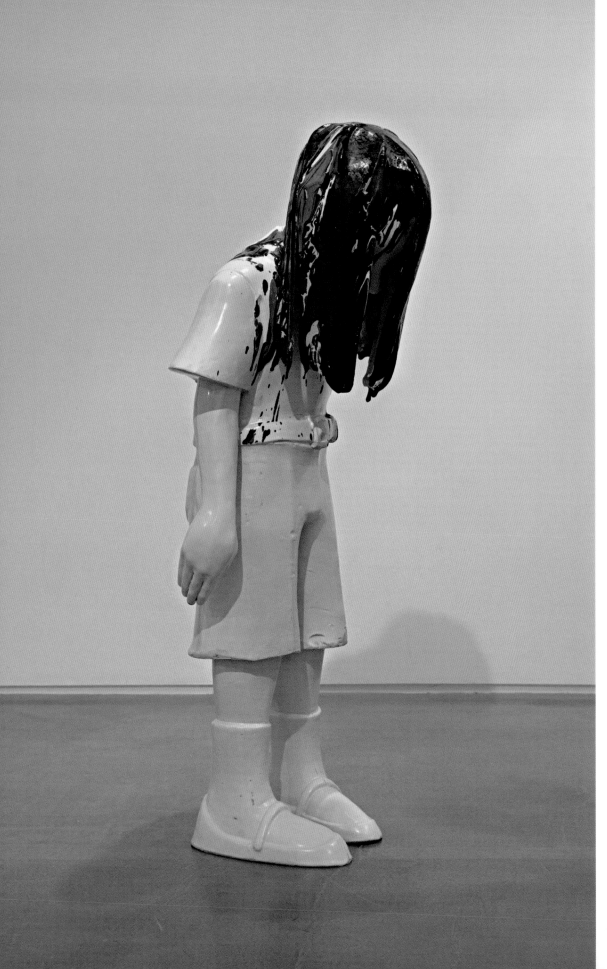

Kim Simonsson

Carrie II, 2009
Glazed stoneware
41 ¼ x 18 ⅞ x 17 ¼ in.
(105 x 48 x 44 cm)
Courtesy of the artist

Kim Simmonson

Opposite:
Untitled, 2013
Courtesy of the artist

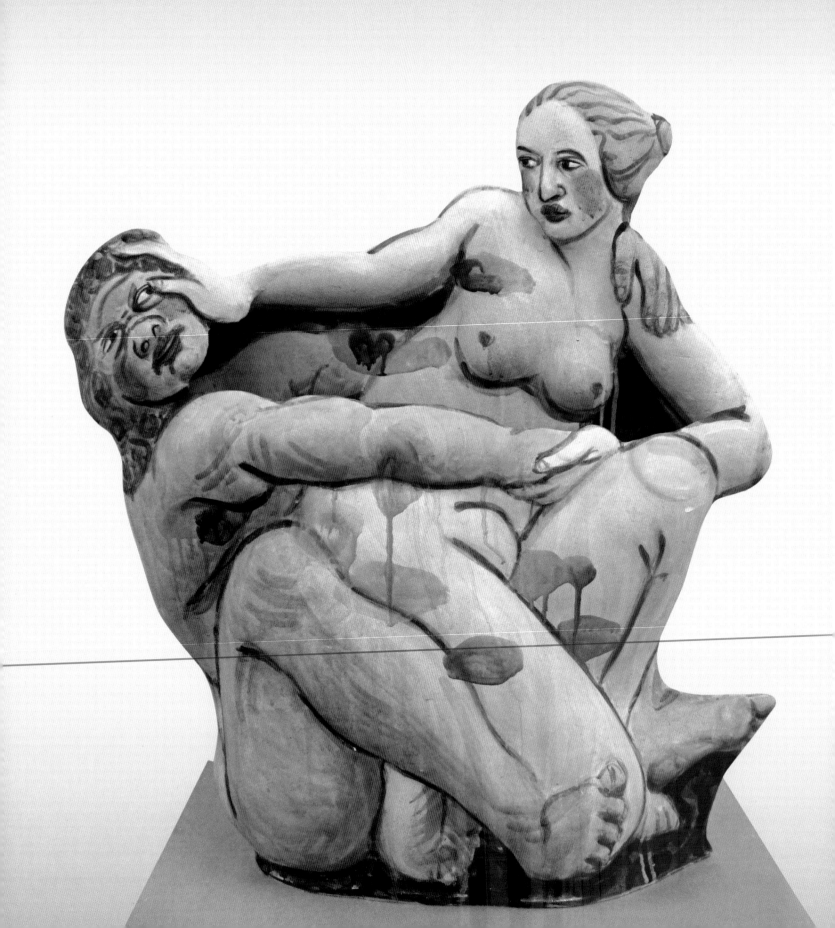

EVEN NOW, I still look closely at the human image.

My works, and the figures in *Nymph and Satyr,* are representations of specific people. They are also icons of their time. I imagine that a figure can look back at the incredible continuum of humans and also see itself as a single object in that timeline. Perhaps it can also look forward, but what it sees it does not reveal. I want to create human figures that stand at the crossroads between accumulated human history and individual identity.

I draw on the surface of clay forms. The material is tactile, and at this point, my strokes are intuitive actions and reactions to it. The process of working with clay gives me many chances to develop and change ideas in situation. So, on a single body, there can be conflicting elements that counterbalance each other and reveal the tension between different moments in time. In *Body & Soul,* love and tenderness are juxtaposed to violence and powerlessness. I like the merging of drawing and material because it activates questions of reality and illusion, function and decoration, description and abstraction.

As time passes, details are forgotten and worn away. What a human figure means now will be different than what it means in the future. It is both the modern person who sees himself as a unique individual and the collective image of the whole of humanity.

A. T.

Akio Takamori (Japanese/American
 b. 1950)

Nymph and Satyr, 2011
Stoneware with underglazes
34 x 25 x 10 in.
(86.4 x 63.5 x 25.4 cm)
Courtesy of Barry Friedman Ltd.,
New York

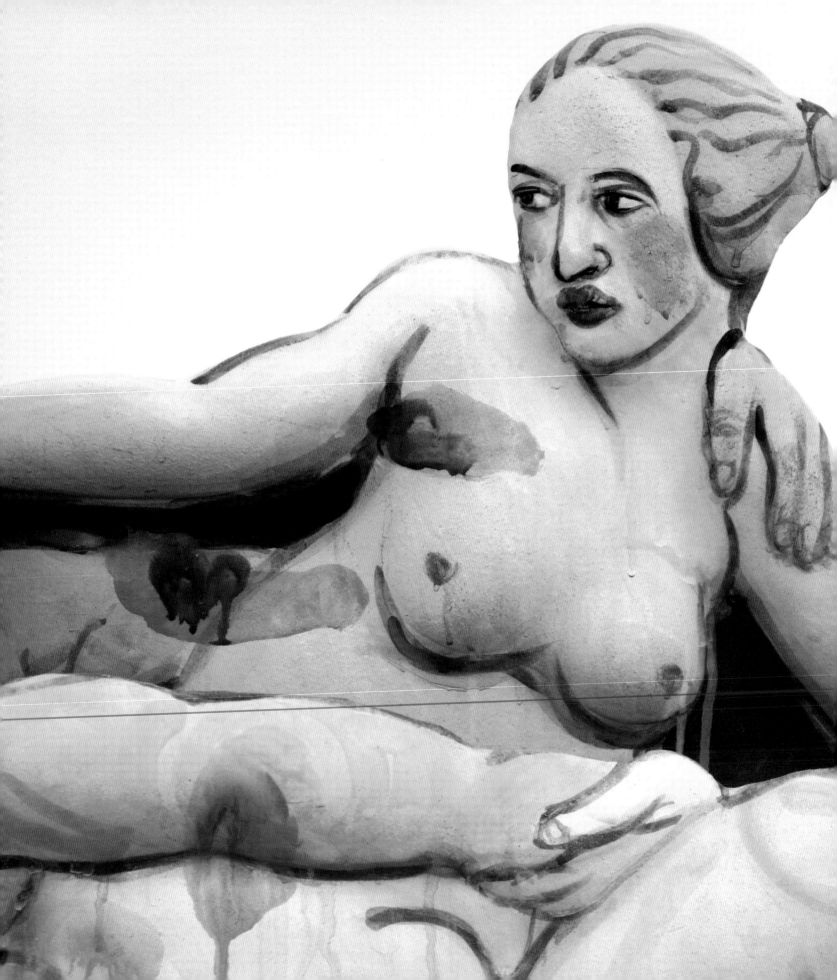

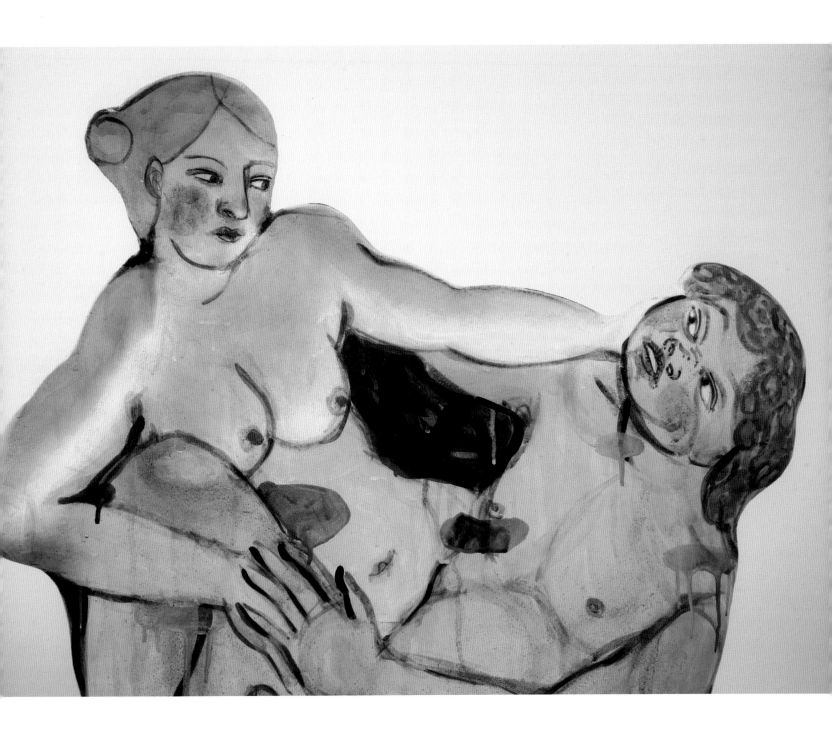

Akio Takamori

Nymph and Satyr (details), 2011
Courtesy of Barry Friedman Ltd.,
New York

I HAVE LOVED the figure, especially the face, for as long as I can remember. As a young teen, I would find interesting faces in the newspaper and attempt to copy them. Through all my school books there are doodles of faces of every sort. I tend to see the figure in clouds, tree bark, stained ceilings. . . . It's been a preoccupation throughout my life.

I can't help but be drawn to the narrative, so every one of the figures has a story. Conceiving the figures begins with thumbnail drawings, which I put down and return to over and over again. The figures that repeatedly hold my attention usually become sculpture. I begin them with a strong sense of their character, but as they develop over the next two months, they often let me know more about themselves and what they would or wouldn't do. Some figures seem to have a strong sense of who they are and seem to dictate their own development. I feel akin to a writer whose characters start to emerge on their own. This is very captivating. Scale and artifacts involved with the figures are of great importance, which becomes clear at the drawing stage.

My overall effort is to realize these figures with as much honesty and tenderness as I can. They are all stand-ins for me, representing some aspect of myself that calls to be reckoned with. They range from extreme to subtle emotional/psychological states, but hopefully all have a vulnerability by which the viewer is touched. My hope is that viewers will recognize something within themselves as they experience each figure and connect with their own humanity.

Sometimes grace can beckon us in disguise. As in *Grace Flirts*, where it comes in the package of a young girl who is chilled, protecting herself yet still flirtatious behind a mask of overt sexuality. Innocent viewers might be drawn to her from an impulse to try and help or warm her, but it is she who holds the reins so that we, the viewer, may come in closer.

Regarding *Boxer*, I wanted to make a bust of a man who appears defeated yet equally determined to fight to the end.

T. T.

Tip Toland (American, b. 1950)

Boxer (detail), 2010
Stoneware, paint, chalk, pastel
14 x 18 x 10 in.
(35.6 x 45.7 x 25.4 cm)
Courtesy of Barry Friedman Ltd.,
New York

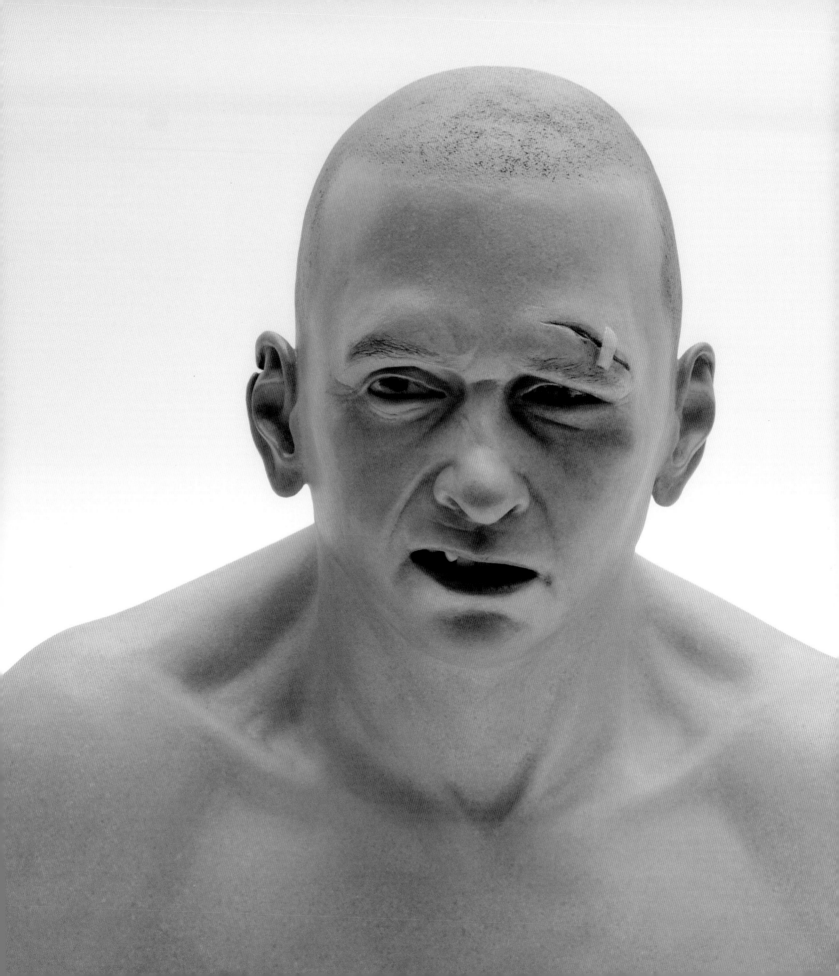

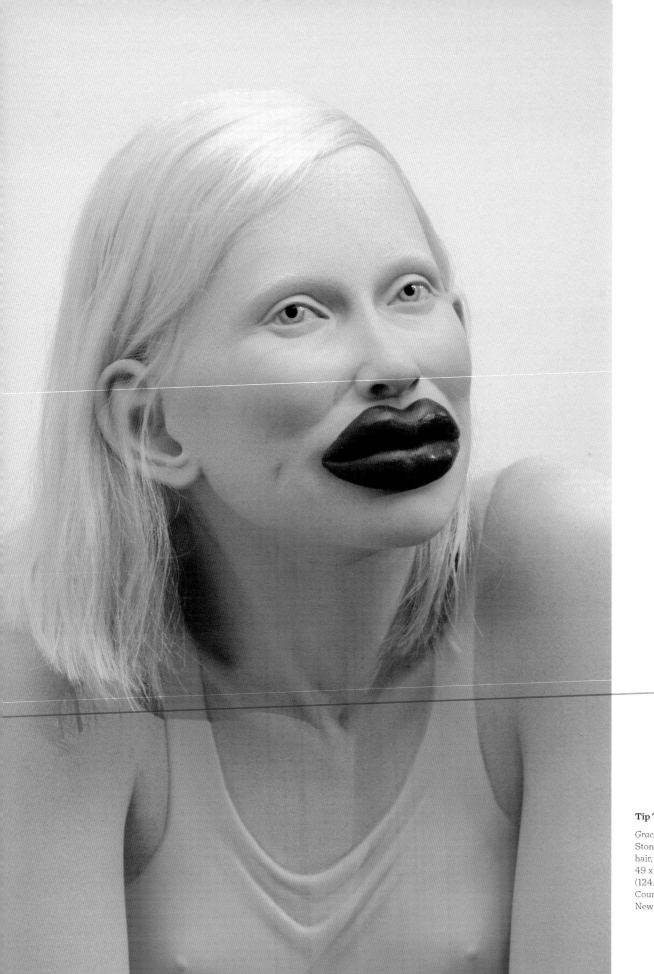

Tip Toland

Grace Flirts (opposite and detail), 2008
Stoneware, paint, pastel,
hair, wax lips
49 x 11 x 14 in.
(124.5 x 27.9 x 35.6 cm)
Courtesy of Barry Friedman Ltd.,
New York

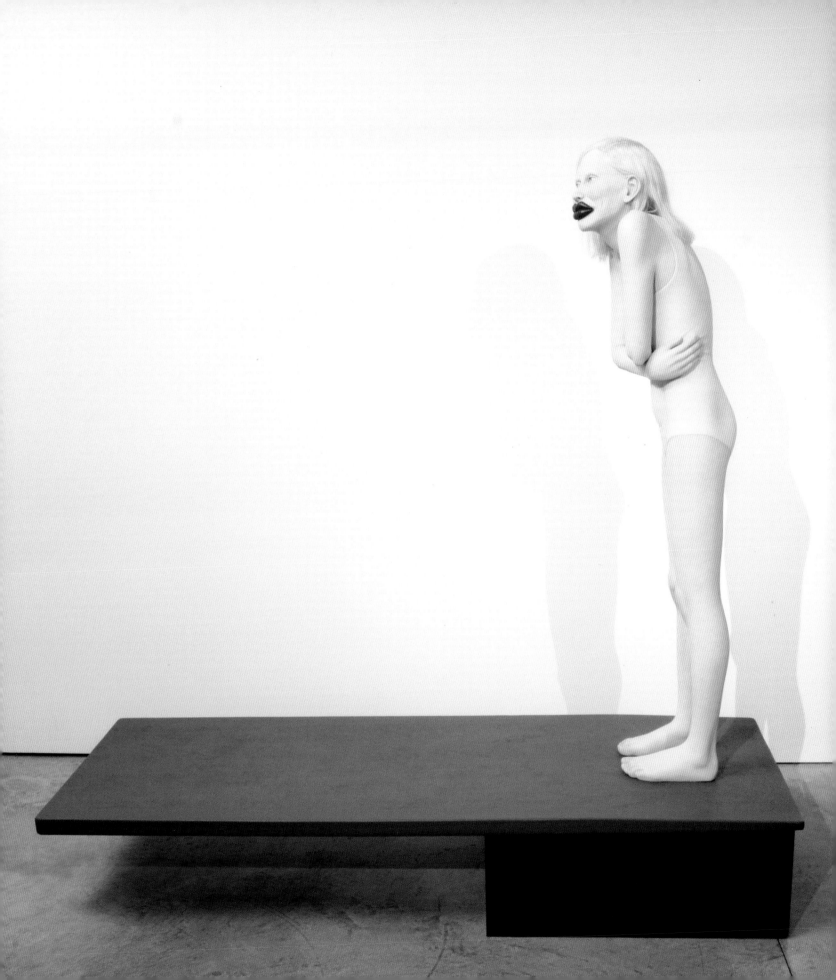

Wendy Tarlow Kaplan is an independent curator based in New York and Boston. She has organized and co-curated more than thirty-five exhibitions and several international traveling exhibitions, including *From the Kilns of Denmark: Contemporary Danish Ceramics*, a landmark exhibition at the Museum of Arts and Design (2002–3); *Tiger by the Tail! Women Artists of India Transforming Culture* (2007), which included several artists later presented at the Pompidou; and *Shoes Tell Stories* (2010). Ms. Kaplan received her B.A. from Smith College and an M.A. from Boston University. She trained at the Museum of Fine Arts, Boston, and served as assistant curator at the Fogg Art Museum, Harvard University. She has also been a curator at the Art Complex Museum in Duxbury, Massachusetts, and at the Women's Studies Research Center of Brandeis University. She has written for art journals and served as a juror and on committees for the DeCordova Museum and the Fuller Craft Museum.

David Revere McFadden is the William and Mildred Lasdon Chief Curator and Vice President for Programs and Collections at the Museum of Arts and Design. He was Curator of Decorative Arts and Assistant Director for Collections and Research at Cooper-Hewitt, National Design Museum, Smithsonian Institution. For six years, he served as President of the International Council of Museums' Decorative Arts and Design Committee. For his work in cultural affairs, Mr. McFadden has been named Knight, First Class, of the Order of the Lion of Finland (1984); Knight Commander of the Order of the Polar Star of Sweden by King Gustaf VI (1988); and Chevalier de l'Ordre des Arts et des Lettres by the Republic of France (1989). Mr. McFadden has received the Presidential Design Award for Excellence three times (1994, 1995, and 1997).

Martin S. Kaplan is a retired partner of Wilmer Cutler Pickering Hale and Dorr, an international law firm, and he has also served as managing trustee of foundations active in grant-making for the arts, culture, and environment. A graduate of Columbia College and Harvard Law School, he served as chair of the Massachusetts Board of Education and has received the University Medal and John Jay Award from Columbia and the Thomas Berry Award for his work in religion and ecology. He has served on non-profit and corporate boards and collects art that reflects a broad range of styles.

Laurent de Verneuil studied art history at University Pantheon-Sorbonne in Paris. He worked with Patrick Favardin for several years and is now a free-lance curator. He was executive director of Galerie Favardin & de Verneuil in Paris until 2012 and consulted with private art collectors in Paris and New York. He has worked on various books and exhibitions, such as *La Lampe Gras*, *Steiner et l'Aventure du design*, and, most recently, *Le Décor est planté* at the Bernardaud Foundation in Limoges. He is currently working on monographs about the Cloutier brothers and Kim Simonsson and on international traveling exhibitions based on the Finnish art scene.

Ronne Hartfield is a poet, essayist, and international museum consultant and the author of the acclaimed biographical memoir, *Another Way Home: The Tangled Roots of Race in One Chicago Family* (University of Chicago Press 2004). She served throughout the 1990s as the Woman's Board Endowed Executive Director for Museum Education at the Art Institute of Chicago and has been a Senior Fellow in Residence at the Rockefeller Scholars Center in Bellagio, Italy, as well as at the Harvard University Center for the Study of World Religion. With undergraduate and graduate degrees from the University of Chicago in history, theology, and literature, she was awarded an Honorary Doctorate in Humane Letters by DePaul University. Ms. Hartfield has been a visiting professor at several universities and has been honored with a range of awards and travel fellowships. She consults widely and is an internationally recognized expert in museum education.

Since 2003 **Peter Held** has been the Curator of Ceramics at the Ceramics Research Center, part of the Arizona State University Art Museum at Tempe. He has curated more than one hundred exhibitions, including ten national traveling shows, and has published numerous articles on contemporary art and craft. He has edited and been a contributing essayist for nine books, including *A Ceramic Continuum: Fifty Years of the Archie Bray Influence* (2001); *Akio Takamori: Between Clouds of Memory* (2005); *Innovation and Change: Ceramics from the ASU Art Museum* (2009); and *Infinite Place: The Ceramic Art of Wayne Higby* (2013). He received the 2007 Ceramic Lifetime Achievement Award from the Friends of Contemporary Ceramics.

Karen and Michael Rotenberg, collectors of contemporary ceramics, are members of the James Renwick Alliance, an organization dedicated to supporting activities that focus on contemporary American craft, including education, connoisseurship, and collecting. They are also members of the Contemporaries Visiting Committee of the Museum of Fine Arts, Boston. Karen is a trustee of the Society of Arts and Crafts and the Institute of Contemporary Art in Boston. She is an overseer at the Museum of Fine Arts, Boston, and a member of the Visiting Committee of the Arts in Education Program of the Harvard Graduate School of Education.

W. Richard West Jr., President and Chief Executive Officer of the Autry National Center of the American West, was Founding Director of the Smithsonian Institution's National Museum of the American Indian, where he was the director from 1990 to 2007. As an attorney, he has served as general counsel and special counsel to numerous American Indian tribes, communities, and organizations, representing clients before federal, state and tribal courts, as well as Congress and the executive branch of the federal government. Mr. West has served on a number of boards, including the Ford Foundation and Stanford University, and he was chair of the board of the American Association of Museums and Vice President of the International Council of Museums. Mr. West, Peace Chief of the Southern Cheyenne tribe, received a master's degree in American history from Harvard University in 1968 and graduated from the Stanford University School of Law in 1971.

Marc Alberghina was born in 1959 in Laval, France, and he now lives and works in Vallauris. In 1978 he received a diploma from the École des Métiers de la Céramique in Cannes. He worked in ceramics production until 1989, when he became an independent visual artist and sculptor.

Alberghina has participated in the Biennale Internationale de Céramique Contemporaine, Vallauris, France (2010), and the Biennale Internationale de Céramique Contemporaine, Châteauroux, France (2013). He has exhibited his work in several recent group exhibitions: at Le Fil Rouge, Roubaix, France (2013); Galerie à Rebours, Paris (2012); the Bernardaud Foundation, Limoges (2011); the Musée des Arts décoratifs, Paris (2011); and Galerie Favardin and de Verneuil, Paris (2011). His work has been acquired by the La Piscine–Musée d'Art et d'Industrie in Roubaix, France, and his work will be exhibited at the Musée Royal de Mariemont for the reopening of the museum in 2015.

Chris Antemann was born in 1970 in Albany, New York, and now works in Joseph, Oregon. She received her MFA in ceramics from the University of Minnesota (2000), and she has since held residencies at the Meissen Porcelain Manufactory in Germany (2012), the Archie Bray Foundation in Montana (2006), and the Jingdezhen Sanbao Ceramic Art Institute in China (2002). Antemann is inspired by eighteenth-century porcelain figurines and employs her designs to examine and parody male and female relationship roles; to create narratives about domestic rites, social etiquette, and taboos; and to attend to the cultural history of the porcelain figurine itself as a design medium. In 2010 she was awarded first prize by the Virginia A. Groot Foundation, and she received an Emerging Artist Grant from the American Craft Council in 2002.

Antemann has exhibited in numerous solo exhibitions, including *Forbidden Fruit: A Porcelain Paradise*, Meissen artCAMPUS Gallery, Meissen, Germany (2013); *Let Them Eat Cake*, Robischon Gallery, Denver, Colorado (2011); and *Battle of the Britches*, Ferrin Gallery, Pittsfield, Massachusetts (2009). She has also participated in group exhibitions at the Gyeonggi International Ceramic Biennale, Gyeonggi, Korea (2013); the Triennale Design Museum, Milan, Italy (2013); the Fuller Craft Museum, Brockton, Massachusetts (2011), and the Bellevue Art Museum, Bellevue, Washington (2010). Her work is in the collections of the Museum of Fine Arts, Boston; the High Museum of Art, Atlanta, Georgia; and the Portland Art Museum, Portland, Oregon.

Damien Cabanes was born in Suresnes, France, in 1959 and now lives and works in Paris. He graduated from the École nationale supérieure des beaux-arts in Paris in 1983. Cabanes is the recipient of public commissions at Lycée Sonia Delaunay, Grigny, France (2004); the Roseraie metro station, Toulouse, France (2000); and the Jardin des Tuileries, Paris (1999). He received the Jean-François Millet Prize in 1999.

Cabanes's solo exhibitions include *Rétrospective*, Musée d'Art Moderne, Saint-Etienne, France (2011); *Corps à corps*, the Salomon Contemporary Art Foundation, Alex, France (2009); and *This Phrase is Chosen with Care*, Mike Weiss Gallery, New York (2007). He has also exhibited in numerous group exhibitions, including those at the Contemporary Art Space, Saint-Restitut, France (2012); the Indonesian National Gallery, Jakarta (2009); Parker's Box Gallery, New York (2009); and elsewhere. His work resides in the collections of the Musée d'Art Moderne, Paris; the Radboud University Nijmegen Medical Centre, Nijmegen, Netherlands; and the Musée Despiau-Wlérick, Mont-de-Marsan, France.

Daphné Corregan was born in 1954 in Pittsburgh, Pennsylvania. She has lived in France since 1970 and now works in Draguignan, France, and Monaco. Throughout the 1970s, she studied at the Écoles des beaux-arts in Toulon, Marseille, and Aix-en-Provence. The human body—or parts of the body—has appeared in her work consistently over the last thirty years, most often sparked by political events, such as the Rwandan tragedy and the war in Afghanistan, or by a more personal upheaval, such as her mother's death. Corregan held residencies with the Sanbao International Ceramic Exchange, Jingdezhen, China (2010); in Fuping, China (2005); and at the Sun Valley Center for the Arts and Humanities, Sun Valley, Idaho (1978). In 1991 she served on a mission in Burkina Faso to work with and document the production of traditional potters.

Corregan's numerous solo exhibitions include *New Works*, Kunstforum Solothurn, Solothurn, Switzerland (2011); *Voyage Américain*, Galerie Nathalie Béreau, Paris (2010); and *Collect*, Victoria & Albert Museum, London (2006). She recently exhibited in group exhibitions at Galerie Hélène Porée, Paris (2012); Brandpunt Terra, Delft, Netherlands (2011); Galerie Gismondi, Paris (2010); and the Bernardaud Foundation, Limoges, France (2009). Her work is in such collections as the Musée des Arts décoratifs, Paris; the Württemberg State Museum, Stuttgart, Germany; Sèvres – Cité de la Céramique, Sèvres, France; and the Pretoria Art Museum, Pretoria, South Africa.

Valérie Delarue was born in Le Mans, France, in 1965 and now lives and works in Paris. She attended the École nationale supérieure des beaux-arts in Paris and studied abroad at the California College of Arts and Crafts in Oakland, California, where she received a diploma in 1994. She is drawn to the medium of clay because of the process of transforming the flexible, skinlike material into hardened, bonelike forms, through which she explores the connections of clay to the body and the impact of the body on clay. She is the recipient of the First Prize in Sculpture from the Florence Gould Foundation, Monte Carlo, Monaco (1995).

Delarue has held several solo exhibitions, including *La Main sur le coeur*, Galerie Michèle Hayem Ivasilevitch, Paris (2013); *Chutes et métamorphoses*, Galerie CROUS, Paris (2001); and *A l'aube du cinquième jour*, Galerie Samedi, Monfort l'Amaury, France (1999). She has participated in group exhibitions at the Musée des Arts décoratifs, Paris (2011); Galerie Duchamp, Yvetot, France (2011); Galerie Alexandre Cadain, Paris (2010, 2009); the Musée de la Céramique, Rouen, France (2006); and elsewhere. Her work resides in the collections of the Musée des Arts décoratifs, Paris, and the Musées de la Cité de Rouen, France.

Laurent Esquerré was born in 1967 in Toulouse, France, and has been working in Paris since 2010. He studied painting and drawing at the École nationale supérieure des beaux-arts in Paris. During a visit in 2000 to Naples, where he studied the techniques of ceramics production, Esquerré turned his attention to sculpture and to clay in particular. He embarked thereafter on a series of figures in glazed pottery, a traditional medium of southwestern France that is still widely practiced today.

Esquerré's solo exhibitions include *Laurent Esquerré*, Galerie de l'École des beaux-arts, Poitiers, France (2012); *Laurent Esquerré*, Galerie Thébault, Bazouges La Pérouse, France (2010); and *Laurent Esquerré, Céramiques et Peintures*, Château de Laréole, Laréole, France (2008). He has shown his work in group exhibitions at Galerie Charlotte Norberg, Paris (2008–2012); the Musées de Châteauroux, Châteauroux, France (2011); the Musée des Arts décoratifs, Paris (2010); and the Gray Gallery, Los Angeles (2010). His work is represented in the lithograph collection of the Bibliothèque nationale de France and the contemporary art collection of the General Council of Haute Garonne, France.

Mounir Fatmi was born in Tangier, Morocco, in 1970 and now lives and works between Tangier and Paris. His work encompasses various media, including painting, sculpture, video, and installations. He addresses current events and their impact on individuals and society at large, often highlighting the fragility of humanity in the face of a society focused on strength, speed, and performance. He has received several prizes, including the Cairo Biennial Prize (2010); the Uriôt Prize, Rijksakademie, Amsterdam (2006); and the Leopold Sedar Senghor Grand Prize of the 7th Dakar Biennial (2006).

Fatmi's solo exhibitions include *Suspect Language*, Goodman Gallery, Cape Town, South Africa (2012); *Megalopolis*, AKBank Sanat, Istanbul (2011); *Seeing is Believing*, Galerie Hussenot, Paris (2010); *Fuck Architecture: Chapter III*, Brussels Biennale, Belgium (2008); and others. He participated in group exhibitions at the Brooklyn Museum, New York (2012); the Arab Museum of Modern Art, Doha, Qatar (2011); the Moscow Museum of Modern Art, Moscow (2010); the Studio Museum in Harlem, New York (2008); the Haus der Kunst, Munich (2008); the Georges Pompidou Centre, Paris (2008); and many others around the globe.

Teresa Gironès is a Catalan ceramicist born in 1941 in Barcelona, Spain. She continues to live and work in her hometown, teaching at the "Llotja" Escuela Oficial de Diseño in Barcelona. She creates large volumes in her ceramic work through the use of chamotte fireclays (grog) and applies screen-printed photographic images to the surfaces. She is the founder and vice president of the Asociación de Ceramistas de Cataluña and was recognized by the Catalan government with the title of Master Potter.

Gironès has participated in more than 200 exhibitions throughout her career of more than forty years to date. Her solo exhibitions include *Altros*, Galerie Terra Viva, Saint Quentin la Poterie, France (2010), and *De l'autre côté du miroir:Teresa Gironès*, Galerie Anagama, Paris (2009). She has participated in group exhibitions at the Museu de Ceràmica, Barcelona (2011); Sèvres – Cité de la Céramique, Sèvres, France (2010); the International Academy of Ceramics, Fuping, China (2008); and other major international institutions. Her work resides in numerous public institutions, such as the Museu de Ceràmica, Barcelona; the Florida Museum of Hispanic and Latin American Art, Coral Gables, Florida; and Sèvres – Cité de la Céramique, Sèvres. Additionally, her work is in several private collectors throughout Europe and America.

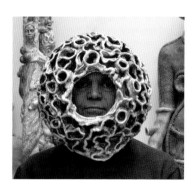

Michel Gouéry was born in 1959 in Rennes, France, and now lives and works in Bagnolet near Paris. He obtained a degree from the École des beaux-arts de Rennes in 1985 and held a residency at the Villa Medici in Rome in 1986. After a long detour through the natural sciences, and another period when he focused on modeling details of the body—intestines, anuses, hearts, phalluses, feet—in the form of votive offerings, anatomical fragments, or heraldic representations, Gouéry began to sculpt complete figures from head to foot.

Gouéry has held numerous solo exhibitions, including *Sortie de Vortex*, ACMCM: Center of Contemporary Art, Perpignan, France (2012); *Le Chaman de Lascaux en One Man Shot*, Galerie Anne de Villepoix, Paris (2009); *Gouéryfication*, Galerie Deborah Zafman, Paris (2008); and *Nouvelles Pointure*, Galerie Trafic, Ivry, France (2006). He participated in group exhibitions at Carré Saint-Anne, Montpelier, France (2013); the Musée des Beaux-Arts, Dunkerque, France (2012, 2011); the Institut Français, Berlin (2011); and the Musée des Arts décoratifs, Paris (2010); among other locations. His work resides in the French public collections of the Regional Contemporary Art Fund, Auvergne, and the Regional Fund for Contemporary Art, Alsace.

Jessica Harrison was born in St. Bees, England, in 1982. She moved to Scotland in 2000 to study sculpture at Edinburgh College of Art, where she completed an MFA and undertook a practice-based PhD in sculpture in 2007, funded by the Arts and Humanities Research Council. She employs various materials to explore the relationship between the interior and the exterior of the human body, ultimately moving away from a binary distinction between the two realms of experience. Harrison was the first artist awarded the position of International Lithography Artist-in-Residence at the Black Church Print studios, Dublin (2008). She was also the recipient of the RSA Sculpture Prize, Royal Scottish Academy, Edinburgh (2007); the John Watson Prize, Scottish National Gallery of Modern Art, Edinburgh (2005); and the Kinross scholarship from the Royal Scottish Academy (2005).

Harrison has exhibited in solo exhibitions, including *Broken*, Jealous Gallery, London (2011); *Jessica Harrison*, Peter Potter Gallery, Haddington, Scotland (2009); and *Collection*, Scottish National Gallery of Modern Art, Edinburgh (2005). She participated in group exhibitions at the Fine Art Society, London (2013); Times Square Gallery, New York (2011); the Halle Saint Pierre Museum, Paris (2011); Aando Fine Art, Berlin (2011); and elsewhere in Europe and America. Her work is in several public collections, including Pallant House Gallery, Chichester, England; Fingal County Public Art Collection, Ireland; the New Art Gallery Walsall, Walsall, England; and the Royal Scottish Academy, Edinburgh, as well as numerous private collections.

Louise Hindsgavl was born in 1973 in Copenhagen, Denmark, where she continues to live and work. She graduated in 1999 from the Department of Ceramics and Glass of the Designskolen, Kolding, Denmark. She is compelled by the history and fragility of porcelain figurines to employ the medium in emphasizing the contrast between the pure and refined material and the untamed figures of her designs. She is the recipient of numerous awards, including a three-year working grant from the Danish Art Foundation (2010); the Silversmith Kay Bojesen and Erna Bojesens Memorial Grant (2009); and the Annie og Otto Johs. Detlefs' Award for Young Ceramicists (2006).

Hindsgavl has held several recent solo exhibitions, including *Human Desires and Last Minute Pleasures*, Galerie NeC, Hong Kong (2013); *Cuts and Bruises*, Gallery SODA, Istanbul (2013); *Setting the Stage*, Copenhagen Ceramics, Copenhagen (2012); and *Last Minute Pleasures*, Galerie NeC, Paris (2012). She has participated in group exhibitions at Puls, Brussels (2012); Brandpunt Terra, Delft, Netherlands (2011); Galerie Dutko, Paris (2010); Nancy Margolis Gallery, New York (2009); and many other galleries and institutions. Her work can be seen in the collections of the Victoria & Albert Museum, London; the Danish Museum of Art & Design, Copenhagen; and the Trapholt Museum of Modern Art, Applied Art, Design and Furniture Design, Kolding, Denmark.

Sergei Isupov was born in Stavropol, Russia, in 1963 and now lives in Cummington, Massachusetts. He received his MFA in ceramics in 1990 from the Art Institute of Tallinn, Estonia. Recently Isupov was an artist-in-residence at the University of Tallinn, Estonia (2007); the International Ceramics Studio, Kecskemet, Hungary (2007); and the Jam Factory, Adelaide, Australia (2006). He received the Louis Comfort Tiffany Biennial Award (2001), as well as the Smithsonian Craft Show Top Award for Excellence, Washington, D.C. (1996), and the "Best Young Estonian Artist" Award, Union of Artists of Estonia (1991).

Isupov has held numerous solo exhibitions worldwide, including *He + She*, Barry Friedman Ltd., New York (2010); *Firmly Standing*, Estonian Museum of Applied Art and Design, Tallinn, Estonia (2010); and *Androgyny, The Preview: Sculpture, Painting, Drawing*, Ferrin Gallery, Pittsfield, Massachusetts (2008). He has shown his work in group exhibitions at Davidson Galleries, Seattle, Washington (2012); SOFA New York, Ferrin Gallery, Pittsfield, Massachusetts (2011, 2012); Fuller Craft Museum, Brockton Massachusetts (2010); and the Fowler Museum at UCLA, Los Angeles, California (2009). His work is represented in many collections, including the Carnegie Museum of Art, Pittsburgh, Pennsylvania; the De Young Museum, San Francisco, California; the Mint Museum of Craft & Design, Charlotte, North Carolina; the Museum of Fine Arts, Boston, Massachusetts; the Oslo Museum of Applied Art, Oslo, Norway; and the National Gallery of Australia, Canberra, Australia.

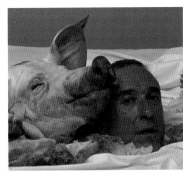

Klara Kristalova is a ceramicist born in 1967 in what was then Czechoslovakia. She was raised in Stockholm, Sweden, and lives today in Norrtälje, Sweden. She graduated from the Royal University College of Fine Art, Stockholm, in 1994.

Kristalova's recent solo exhibitions include *Klara Kristalova*, Västerås Art Museum, Västerås, Sweden (2013); *Wild Thought,* Galerie Perrotin, Paris (2012); *Sounds of Dogs and Youth,* Lehmann Maupin, New York, (2011); *New Work Series*, San Francisco Museum of Modern Art, San Francisco, California (2011); and *Where the Owls Spend Their Days*, Galerie Alisson Jacques, London (2009). She has participated in group exhibitions at institutions and galleries such as the San Francisco Museum of Modern Art (2011); the Lehmann Maupin Gallery, New York (2010); and the Salomon Contemporary Art Foundation, Alex, France (2009). Her work is represented in such collections as the Moderna Museet, Stockholm; the Nationalmuseum, Stockholm; and Bror Hjorth's House, Uppsala. In 2006 Kristalova was selected to create public commissions in a public garden-park in Tungelsta, Stockholm, and in the Stockholm residential area of Svedmyra.

Saverio Lucariello is an installation and mixed-media artist who was born in 1958 in Naples, Italy, and now works between Paris and Marseille, France. He studied at the Academy of Fine Arts, Naples, and at the School of Architecture, Naples. He has taught courses at the École nationale supérieure des beaux-arts, Marseille, France.

Lucariello has held several solo exhibitions, including *Coquillages et croustacées MIAM*, Sète, France (2008); *Saverio Lucariello*, TZR Galerie, Düsseldorf, Germany (2007); and *Saverio Lucariello*, Villa Arson, Nice, France (2007). He has shown his work in group exhibitions at the Biennale de Lyon, France (2007); the National Museum of Contemporary Art, Bucharest, Romania (2007); the Jeu de Paume, Paris (2006); and other institutions and galleries throughout Europe. His work resides in the collections of the Artothèque, Lyon, France; National Fund for Contemporary Art, Paris; and the Municipal Fund for Contemporary Art, Marseille.

Kate MacDowell is a ceramicist based in Portland, Oregon. She was born in 1972 in Santa Barbara, California, and received degrees in literature and English from Brown University in the 1990s. Over the last decade, her artistic career has included the John Michael Kohler Arts/Industry Residency, Sheboygan, Wisconsin (2012), and the Kiln God Residency, Watershed Center for the Ceramic Arts, Newcastle, Maine (2007). MacDowell is an avid hiker, and her hand-built porcelain sculptures respond to environmental threats and their consequences. She is the recipient of several awards, including the Best of Show, Feats of Clay, Lincoln Arts and Culture Foundation, Lincoln, California (2009); the Visionary Award of Excellence, CraftForms, Wayne Art Center, Wayne, Pennsylvania (2008); and the Individual Merit Award, Craft Biennial, Oregon College of Art and Craft, Portland, Oregon (2007).

MacDowell has mounted solo exhibitions that include *Fragile Endurance*, John Michael Kohler Arts Center, Sheboygan, Wisconsin (2013); *After Eden*, Beet Gallery, Portland, Oregon (2008); and *Window Project II*, Blackfish Gallery, Portland, Oregon (2008). Her participation in group exhibitions encompasses shows at the Vögele Culture Center, Pfäffikon, Switzerland (2013); Galerie Vanessa Quang, Paris (2013); the Seattle Design Center, Seattle, Washington (2012); and Marianne Boesky Gallery, New York (2011). Her work is included in numerous private collections throughout the United States.

Myriam Mechita was born in 1964 in Strasbourg, France, where she obtained a degree from the École des arts décoratifs in 1997. She lives and works today in Paris and teaches at the École des beaux-arts de Caen. She has held numerous residencies in such institutions as La Manufacture nationale de Sèvres, France (2009–2010); La Maison des Arts Georges Pompidou, Cajarc, France (2006); and Le Fonds Régional d'Art Contemporain (FRAC), Franche-Comté, France (2005).

Mechita's solo exhibitions include *Myriam Mechita: COMMA 31*, Bloomberg SPACE, New York (2011); *L'infini en plus*, Galerie de Sèvres, Paris (2011); *Lettre à l'inconnu*, Le Parvis scène nationale Tarbes Pyrénées, Centre Méridien, France (2010); *Les semblants à découverts ou I'm an animal without fear*, Micro Onde centre d'art, Vélizy-Villacoublay, France (2009); and *Désirer la flamme avant le brasier*, Galerie Eric Dupont, Paris (2006). She has participated in group exhibitions at Musée des Arts et Traditions, Sète, France (2010); FRAC Basse Normandie (2009); KUMUKUMU Gallery, New York (2008); and Bongoût, Berlin (2008). Her work can be seen in the permanent collections of the Strasbourg Museum of Modern and Contemporary Art, France; the Domaine départemental, Chamarande, France; and the Museum Frieder Burda, Baden-Baden, Germany.

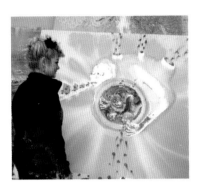

Marlène Mocquet was born in 1979 in Maison Alfort, France. In 2006 she graduated from the École nationale supérieure des beaux-arts in Paris, where she continues to live and work today. Mocquet is the recipient of the Prix Pierre Cardin, Académie des Beaux-Arts, Institut de France, Paris (2008); the Prix Hiscox, France (2007); and the Prix Alphonse Cellier, Académie des Beaux-Arts, Institut de France, Paris (2007). She was an artist-in-residence at the ceramics museum of Sèvres – Cité de la Céramique, Sèvres, France (2011–2012).

Mocquet has mounted numerous solo exhibitions, including *Project Room*, Haunch of Venison, New York (2012); *Marlène Mocquet*, FEAST Projects, Hong Kong (2012); and *Jeux de dames–Marlène Mocquet–Jeanne Susplugas*, Château de Jau, Cases-de-Pène, France (2009). Her participation in group exhibitions includes shows at Carrousel du Louvre, Paris (2012); Center for Contemporary Arts, Prague, Czech Republic (2012); Galerie des Galeries, Galeries Lafayette, Paris (2011); and the Musée des beaux-arts de Nancy, France (2009). Her work resides in the collections of the Fonds National d'Art Contemporain (FNAC), Paris, and the Fonds Municipal d'Art Contemporain de la Ville de Gennevilliers, France.

Sana Musasama is a ceramicist living in her hometown of New York City. She received an MFA from the New York State College of Ceramics at Alfred University in Alfred, New York, in 1987. When studying the pottery of the Mende in Sierra Leone during the 1970s, Musasama learned of the practice of genital mutilation, which led her to investigate women's issues, such as foot binding, rape, prostitution, and female circumcision, in her work.

She has held residencies at the Wadastick Art Center, El Potrero, Mexico (2001); Lasuente Studio Space, Costa Rica (2000); and the Vermont Studio Center, Johnson, Vermont (1999). Solo exhibitions of Musasama's work include *The Hand*, Meta House Gallery, Phnom Penh, Cambodia (2010); *Women*, Chatham University, Pittsburgh, Pennsylvania (2009); and *Unspeakable*, Frankie G. Weems Art Gallery, Meredith College, Raleigh, North Carolina (2008). She has recently participated in group exhibitions at the Givat Haviva Jewish-Arab Center for Peace, Israel (2010) and the Hood Museum of Art, Dartmouth College (2010). Her work can be seen in the collections of the Cooper Hewitt National Design Museum, New York; Jingdezhen Ceramic Institute, Jingdezhen, China; the Studio Museum, Harlem, New York; the Mint Museum of Craft & Design, Charlotte, North Carolina; and others worldwide. Her mosaic work is also permanently installed at the Woodbourne Center, Baltimore, Maryland; the Manchester Craftsmen's Guild, Pittsburgh, Pennsylvania; and the Earl W. Brydges Artpark State Park, Lewiston, New York.

Anne Rochette was born in 1957 in Oullins, France, and currently lives in Paris. She received a a diploma in plastic arts from the École nationale supérieure des beaux-arts in Paris and a Master of Arts from New York University. Rochette has taught at prestigious arts institutions, including Parsons The New School of Design, New York; Rhode Island School of Design, Providence; Tyler School of Art, Temple University, Philadelphia, Pennsylvania; and the École nationale supérieure des beaux-arts, Paris. She is the recipient of several awards: Léonard de Vinci, Ministère des Affaires étrangères (1993); New York Foundation for the Arts, Sculpture (1991); and National Endowment for the Arts, Sculpture (1990).

Rochette has participated in several recent exhibitions, including her solo show, *Ecarts*, L'Espace d'art Camille Lambert, Juvisy-sur-Orge, France (2012), and group exhibitions at the Musée des Arts décoratifs, Paris (2010–2011); the Center for Contemporary Art, Montbéliard, France (2010–2011); and elsewhere. She has received several public commisions for sculptures in the Sculpture Park, National University of Australia, Canberra (2003); Sources de l'Ill, Winkel, France (2003); and the Jardin des Tuileries, Paris (2000).

Coline Rosoux was born in 1984 in Fontenay le Comte, France. She received a diploma in plastic expression from the École des beaux-arts, Angers, France (2008). In 2010 she received a master's degree in ceramics from École nationale supérieure des arts visuels de La Cambre, Brussels, and she continues to live and work in Brussels today.

Rosoux recently held a solo exhibition, *Coline Rosoux: La Sainte Famille*, at Galerie Michele Hayem Ivasilevitch, Paris (2013). She has participated in group exhibitions at La Médiatine, Brussels (2012); Sèvres – Cité de la Céramique, Sèvres, France (2011); Musée Royal de Mariemont, Morlanwelz, Belgium (2011); Chapelle des pénitents noirs, Aubagne, France (2009); and Arums Galerie, Paris (2008).

Elsa Sahal is a ceramicist born in 1975 in France. In 2000 she finished her studies at the École nationale supérieure des beaux-arts in Paris, where she resides today. She has held several artist-in-residence positions at such institutions as the New York State College of Ceramics, Alfred University, Alfred, New York (2009–2010); Le Vent des forêts, Espace rural d'art contemporain, Fresnes-au-Mont, France (2009); and La Manufacture nationale de Sèvres, France (2007–2008). She is the recipient of the Prix MAIF for sculpture (2008) and the Prix de la sculpture contemporaine, Fondation Francesco Messina, Casabeltrame, Italy (2007).

Sahal has held solo exhibitions, including *Elsa Sahal*, Claudine Papillon Galerie, Paris (2012); *Fontaine*, Jardin des Tuileries, Paris (2012); and *Sculptures*, Fondation d'entreprise Ricard, Paris (2008). Her participation in group exhibitions includes shows at SongEun Art Space, Séoul, South Korea (2013); Museé des Arts décoratifs, Paris (2010); and Palazzo Cafarelli, Rome (2009).

Kim Simonsson, born in Finland in 1974, began perfecting his typically all-white aesthetic at a young age: he made his first sculpture out of snow in the backyard of his childhood home. Since he completed his MA studies at the University of Arts and Design Helsinki, Finland, in 2000, his works have taken on a much more dramatic subject matter, using an aesthetic that he has dubbed "Finnish quasi-manga," which indicates his curiosity in Japanese animation and comic style.

Simonsson's recent solo exhibition history includes *Kim Simonsson*, Galerie Favardin & de Verneuil, Paris (2012); *Chameleon*, Galleria Heino, Helsinki (2012); *Ponytail*, Nancy Margolis Gallery, New York (2011); and *A Parallel Reality by Kim Simonsson*, Musée d'Ansembourg, Belgium (2010). His resume of group exhibitions include *Reflective Shadow*, Ordrupgaard, Copenhagen (2011); *The Figuratives*, Oude Kerk, Delft, Netherlands (2011); *Korero*, Taiwan Ceramics Biennale, Yingge Ceramics Museum, Yingge, Taiwan (2010); and *Best of Wonderland*, Wonderland Art Space, Copenhagen (2010), among many others. His works can be found in many renowned collections, including the Victoria & Albert Museum, London; National Museum of Art, Architecture, and Design, Oslo, Norway; Racine Art Museum, Wisconsin; Kiasma Museum of Contemporary Art, Helsinki, to name a few. Simonsson currently lives and works between Helsinki and Fiskars.

Akio Takamori , born in 1950, in Nobeoka, Japan, began studying ceramics when he apprenticed with master folk potter Kyushu Koishiwara in 1971. While learning the craft of industrial ceramics, he saw an exhibition of contemporary ceramic art from Latin America, Canada, and the United States. Amazed by what he describes as the "antiauthoritarian" quality of the work, Takamori questioned his future as an industrial potter. Soon after, the renowned American ceramicist Ken Ferguson encouraged him to study at the Kansas City Art Institute, in Kansas City, Missouri. Takamori received a BFA from there in 1976 and earned his MFA from New York State College of Ceramics at Alfred University, Alfred, New York, in 1978.

Takamori's international history includes recent solo exhibitions at Barry Friedman Ltd., New York (2012); James Harris Gallery, Seattle, Washington (2011 and 2009); Sint-Lucas Beeldende Kunst, Gent, Belgium (2009); and the Frank Lloyd Gallery, Santa Monica, California (2007). Among his most recent group exhibitions are *Hiding Places: Memory in the Arts*, John Michael Kohler Arts Center, Sheboygan, Wisconsin (2011); *Terra-Cotta, Primitive Future, Clayarch* Gimhae Museum, Gyeongsangnam, Korea (2011); and *Magnificent Gifts*, Nelson-Atkins Museum of Art, Kansas City, Missouri (2010). His work can be viewed in the collections the Archives of American Art, Smithsonian Institution, New York and Victoria & Albert Museum, London, among many others. Takamori currently is a ceramics professor at the School of Art, University of Washington.

Tip Toland was born outside of Philadelphia in 1950 and now lives in Vaughn, Washington. Although her academic focus in art began with drawing, she received her MFA in ceramics from Montana State University in 1981, as the medium of clay allowed her to enhance the illusions she was trying to capture in drawing. In addition to being a studio artist, Toland is a part-time instructor in the Seattle area and conducts workshops across the United States, Europe, and the Middle East.

Toland had her first solo exhibition in 1982 and has most recently exhibited at venues that include Barry Friedman Ltd., New York (2012); Bellevue Art Museum, Bellevue, Washington (2008); Pacini Lubel Gallery, Seattle, Washington (2007); and Nancy Margolis Gallery, New York (2005). Toland's recent group exhibition history includes *The Realm of the Feminine: Interior Edge*, Gage School of Art, NCECA, Seattle (2012); *BAM Biennial 2010 Clay Throwdown*, Bellevue Arts Museum, Bellevue, Washington (2010); *Corporeal Manifestations*, The Mutter Museum, Philadelphia (2010), among many others. Her work is represented in both private and public collections, including the Renwick Gallery of the Smithsonian American Art Museum, Washington, D.C.; John Michael Kohler Art Center, Sheboygan, Wisconsin; and the Metropolitan Museum of Art, New York.

Photography Credits

Artists
Photos of artists are on pp. 116–121; this photocredit is given first in each entry below or, in the case of a single photocredit, is included among the photographs taken or provided by the photo source.

Marc Alberghina
Courtesy of the artist (all photos)

Chris Antemann
Courtesy of the artist (photo of artist); Kendrick Moholt (*Feast of Impropriety*); Mark LaMoreaux (*Lust & Gluttony*)

Damien Cabanes
Courtesy of the artist (photo of artist); Adam Cohen (photos of works)

Daphné Corregan
Gilles Suffren (all photos)

Valérie Delarue
Courtesy of the artist (photo of artist); © 2013 Artists Rights Society (ARS), New York / ADAGP, Paris (photos of works)

Valérie Delarue
Courtesy of the artist (all photos)

Laurent Esquerré
Christian Sarramon (photo of artist); Bertrand Hugues (photos of works)

Mounir Fatmi
Zarhloul for Studio Fatmi (all photos)

Teresa Gironès
Courtesy of the artist (photo of artist); Xavi Padrós (photos of works)

Michel Gouéry
Courtesy of the artist (all photos)

Jessica Harrison
Courtesy of the artist (all photos)

Louise Hindsgavl
Anne Mie Dreves (photo of artist); Anders Sune Berg (photos of works)

Sergei Isupov
Courtesy of the artist (photo of artist); Barry Friedman Ltd., New York (*The Orchard*; *St. Valentine*; *Belief and Hope*); Andrew Bovasso (*The Challenge*)

Klara Kristalova
Courtesy of the artist (photo of artist); Christopher Burke Studios (*On the Sunny Side*; *Growing*); Courtesy of the Speyer Family Collection, New York (*Hollow*)

Saverio Lucariello
Guillaume Grasset (photo of artist; *Untitled*; *Vanitas au Poisson*); Courtesy of the artist (*Tripode*)

Kate MacDowell
Kohler Arts/Industry Program (photo of artist); Dan Kvitka (photo of work)

Myriam Mechita
Rebecca Fanuele (photo of artist); Gerard Jonca (photos of works)

Marlène Mocquet
Wendy Tarlow Kaplan (photo of artist); Courtesy of the artist (photos of works)

Sana Musasama
Courtesy of the artist (photo of artist); Roy Steele (photos of works)

Anne Rochette
Anke Mueffelmann (photo of artist); Courtesy of the artist (photos of works)

Coline Rosoux
Courtesy of the artist (photo of artist; details of *L'Assaut*); Martine Beck Coppola (*L'Assaut*)

Elsa Sahal
Courtesy of the artist (photo of artist); © Denis Amon (photos of works)

Kim Simonsson
Jefunne Gimpel (photo of artist); Courtesy of the artist (photos of works)

Akio Takamori
Vicky Takamori (all photos)

Tip Toland
Courtesy of the artist (photo of artist); Andrew Bovasso (photos of works)

Marc Alberghina

Autoportrait A (Self-portrait A), 2011
Courtesy of the artist

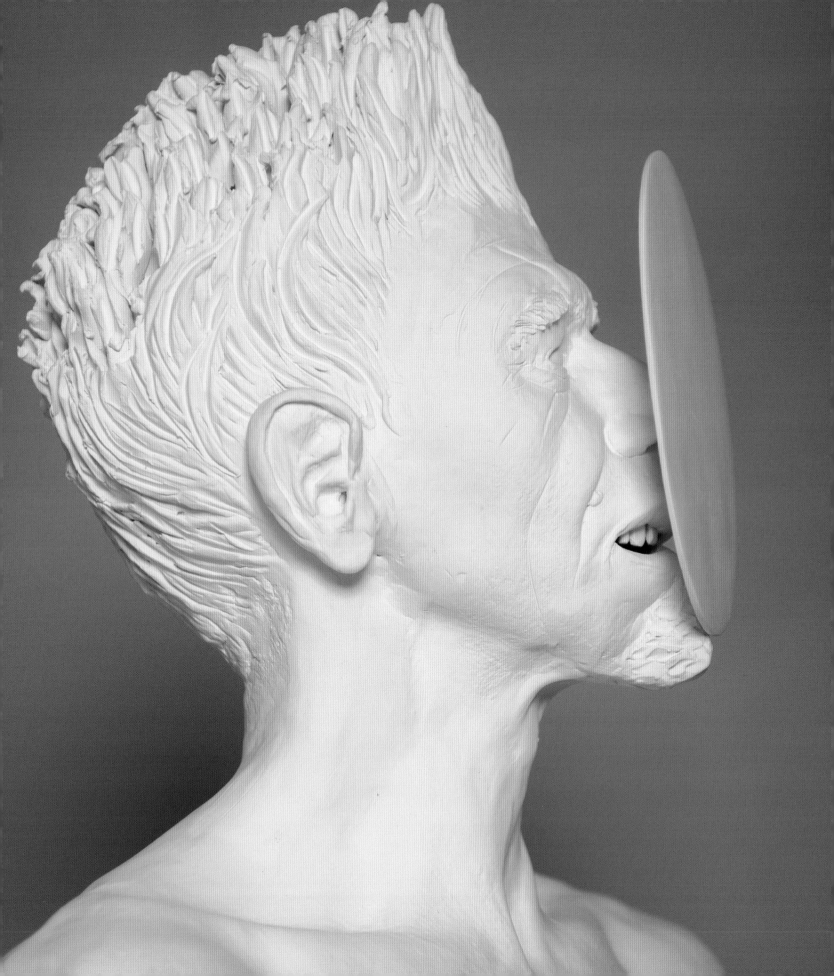

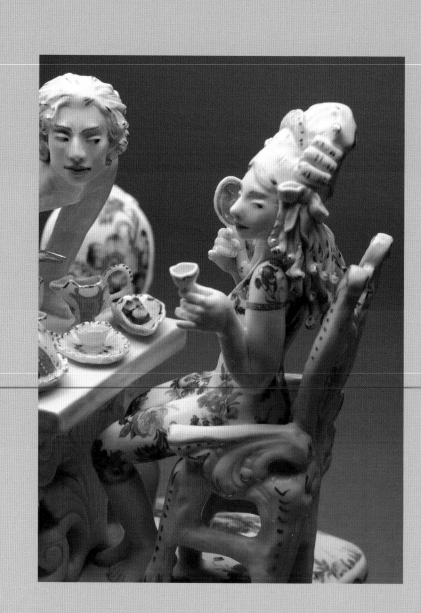

Chris Antemann

Lust & Gluttony (detail), 2008
Museum of Arts and Design
purchase with funds provided by
Nanette L. Laitman, 2008